MANGA MANIA™
CHIBI AND FURRY
CHARACTERS

CHRISTOPHER HART

How to Draw the Adorable Mini-People and Cool Cat-Girls of Japanese Comics

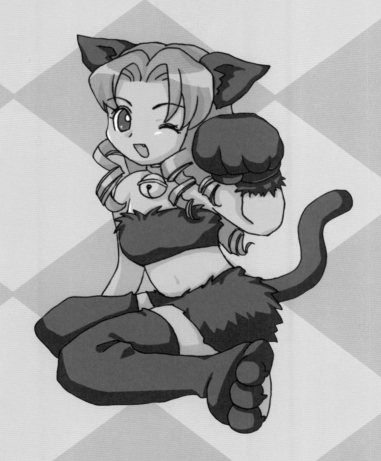

WATSON-GUPTILL PUBLICATIONS/NEW YORK

For Isabella and Francesca

Thanks to all the chibis at
Watson-Guptill Publications.

Executive Editor: Candace Raney
Editor: Anne McNamara
Designer: Bob Fillie, Graphiti Design, Inc.
Production Manager: Hector Campbell

Published in 2006 by
Watson-Guptill Publications, an imprint of the Crown Publishing Group,
a division of Random House, Inc., New York
www.crownpublishing.com
www.watsonguptill.com

Library of Cataloging-in-Publication Data
Hart, Christopher
 Manga mania Chibi and furry characters: how to draw the adorable
 mini-people and cool cat-girls of Japanese comics/Christopher Hart.
 p. cm.
 Includes bibliographical references and index.
 ISBN 0-8230-2977-8 (alk. paper)
1. Cartoon characters. 2. Cartooning—Technique. 3. Comic books
and strips, etc.—Japan—Technique.
I. Title.
MC1764.5.J3H369288 2006
741.5—dc22
 2005023763

Printed in China

6 7 8 9 / 14 13 12 11 10 09

CONTRIBUTING ARTISTS:

Vanessa Duran: 1, 4, 6, 38–39
Chihiro Milley: 2,3, 26–37, 50–55, 138–143
Paulo Henrique Rodrigues: 8–25
Svetlana Chmnakova: 40–49, 130–137
Roberta Peres Massensini: 56, 60–71, 84–85
Park Sung Pal: 57–59, 72–83
Makiko Kanada: 86-111
Yurie Sugiyama: 112–129

Color by MADA Design, Inc.

VISIT US AT

www.artstudiollc.com

Contents

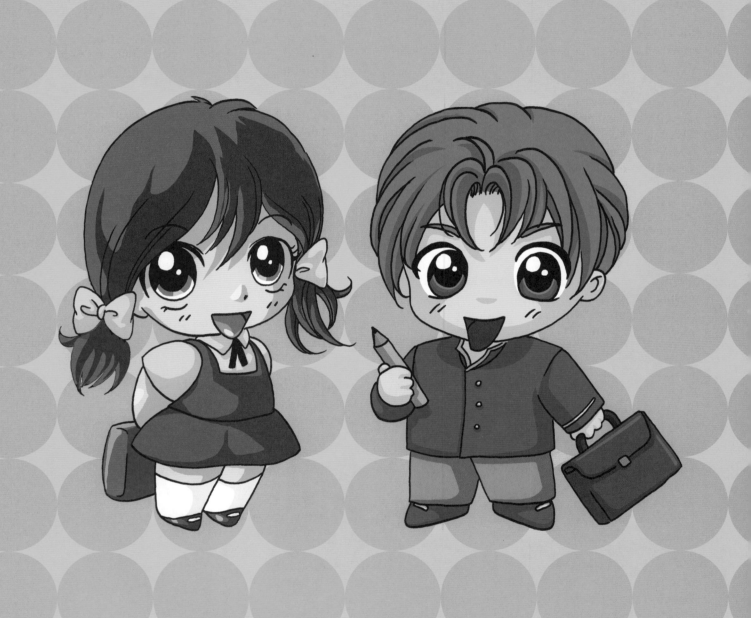

Introduction

Welcome to the fantastic world of chibis and furry characters. Chibis are the adorable tiny people that are the hottest, new sensation of manga. Chibis are cheerful, adorable, naughty, mischievous, excitable, and, in a word, just plain fun. From Japan to America and all across the world, everyone loves chibis!

Chibis have exaggerated proportions that make them squeezable and cute. But chibis aren't only for kids. There are chibis of all varieties, in all roles and genres of manga. There are chibi teenagers, fairies, witches, schoolgirls, fantasy fighters, space commanders, mermaids, athletes, evil geniuses, devils, angels—and everything in between! This book will guide you, step-by-step, through the development of all types of chibi characters, and give you the tools to invent your own chibis. You will learn how to infuse your chibis with personality, and how to draw authentic costumes for them.

And as a special feature that you'll find only in this book, included is an exclusive look at the newest trend out of Japan: the super-stylized chibi. This eye-catching, authentic Japanese style is a must-have for any manga artist who wants to stay on top of his or her game.

We'll also turn our attention to the incredibly popular subject of chibi-style monsters, which are small, yet powerful creatures. These creatures often work with their human pals to defeat the bad guys—and in some cases—the good guys! You'll learn how these characters are often based on simple animals and inanimate objects. You'll also learn how to draw the super-powers and special effects that make chibi-style monsters such stars.

This book also features furry characters, which are sometimes known as "anthros" (short for "anthropomorphic"). The most popular of these manga characters is the famous cat-girl. Cat-girls are attractive characters who retain their human posture but also have cat-like physical traits. There are several types of cat-girls. Some look more human, while others look more like cats. You'll learn how to draw them in a way that maintains the character's attractiveness and appeal. Cat-girls can also be drawn chibi-style, which is demonstrated in this book. They're used in many different genres of manga, including girls' comics, boys' comics, and science-fiction.

But that's not all! We also cover the popular technique of "super-deforming" ordinary manga characters into chibis. These super-deformed chibis are used by many of the top Japanese manga artists to make wisecracks about the comic book story from the corners of the comic book panels. This is a hilarious section, filled with jokes that are sure to generate laughs. Don't miss it!

Chibis are like puppy dogs—people melt when they see them. Whether you are drawing them to tug at the heartstrings, or to get some laughs, you'll have a great time working with this book.

CHIBI BASICS

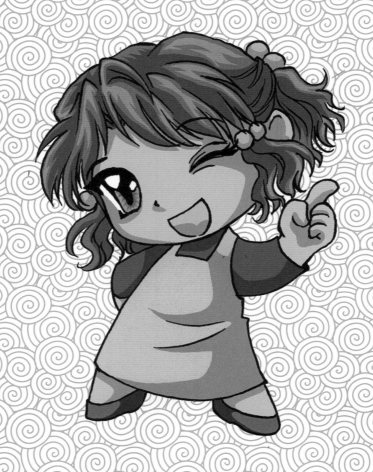

A chibi is a lot more than a miniature person. If you were to shrink a regular-sized person down to the size of a chibi, it wouldn't work. Chibis have a very specific look. In this chapter, I will introduce you to some of the basic proportions and characteristics of a Chibi. You'll see what makes a chibi character different from a regular manga character—from the obvious size difference to more specific features.

What Makes a Chibi, a Chibi?

Chibi characters vary widely—as widely as characters in any other genre of manga, and yet, all chibis have particular traits that they share in common. Once we recognize these traits, we can begin creating these adorable, high-energy people that have become so popular.

When you think of chibis, think of four things: Think big, think simple, think round, and think chunky.

• **Think big**, because chibi heads are much bigger in relation to the size of their bodies than the standard manga character's head. While a normal-size person is six- to seven-heads tall, and regular comic characters can be as little as four-heads tall, chibis are only two- to three-heads tall. Therefore, their heads look huge on their tiny, little bodies.

• **Think simple**, because things that are cute are simple. Take, for example, the fists on the boy chibi fighter. They have been simplified so that you don't see the individual fingers. His arms have also been simplified: The muscular definition has been eliminated.

• **Think round**, because the rounder something is, the younger it looks. The heads of all baby animals are very round, and elongate as the animal matures. Plus people respond positively to round shapes (because they are non-threatening).

• And, finally, **think chunky**, because chibis are never skinny, but tend to be slightly chubby (or at least, have a little tummy, which gives them that dear, sweet, innocent look that is so appealing to readers).

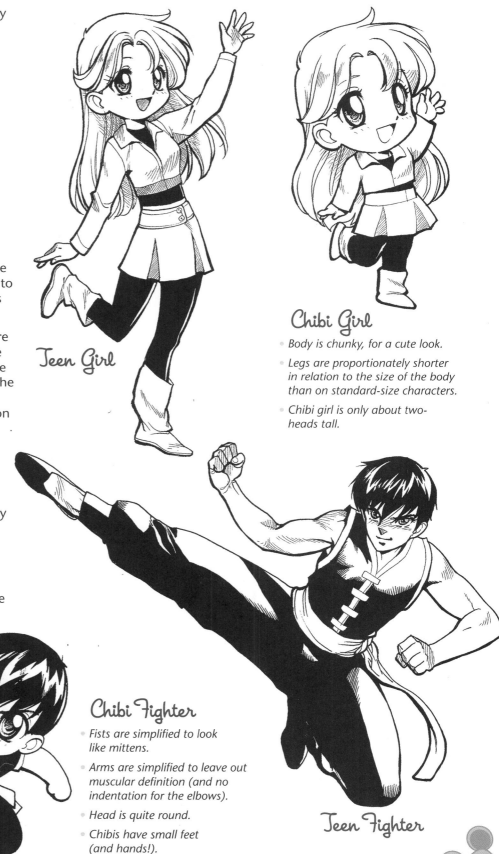

Teen Girl

Chibi Girl

- Body is chunky, for a cute look.
- Legs are proportionately shorter in relation to the size of the body than on standard-size characters.
- Chibi girl is only about two-heads tall.

Chibi Fighter

- Fists are simplified to look like mittens.
- Arms are simplified to leave out muscular definition (and no indentation for the elbows).
- Head is quite round.
- Chibis have small feet (and hands!).

Teen Fighter

The Chibi Head

We've already discussed how chibi heads are proportionately larger in relation to their bodies than standard-size manga characters' heads, and that they are round and simplified. Now, let's take it a step further and identify the specific features of the face that make chibis different from standard manga characters.

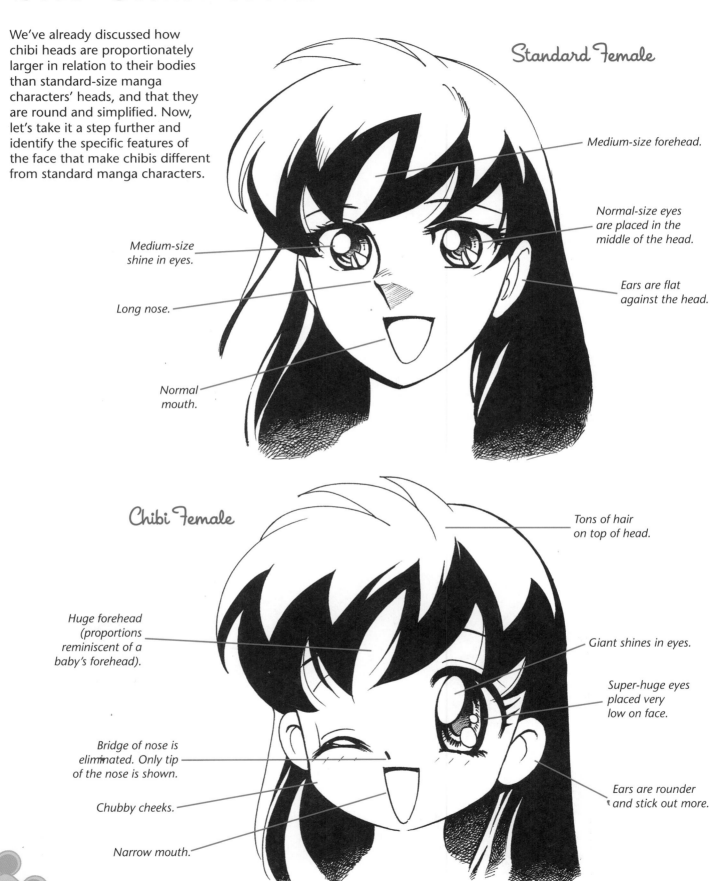

Standard Female

Medium-size forehead.

Normal-size eyes are placed in the middle of the head.

Ears are flat against the head.

Medium-size shine in eyes.

Long nose.

Normal mouth.

Chibi Female

Tons of hair on top of head.

Huge forehead (proportions reminiscent of a baby's forehead).

Giant shines in eyes.

Super-huge eyes placed very low on face.

Bridge of nose is eliminated. Only tip of the nose is shown.

Chubby cheeks.

Ears are rounder and stick out more.

Narrow mouth.

The same characteristics that define the female chibi's head apply to the male chibi's as well. Here are a few additional observations for you to note.

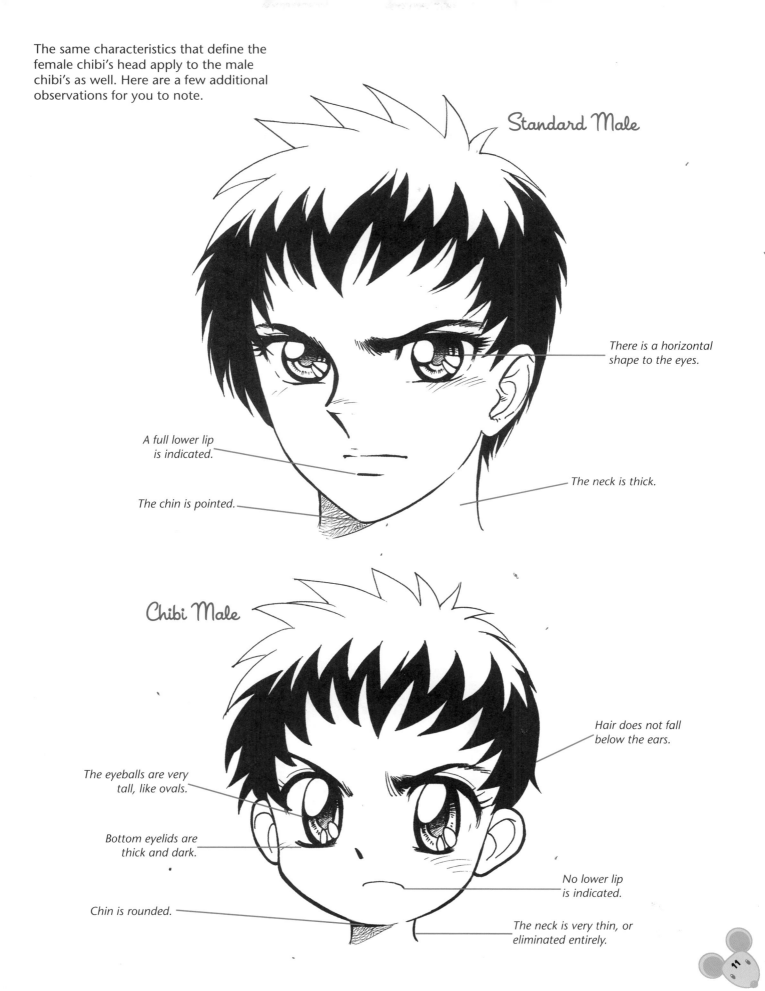

Standard Male

There is a horizontal shape to the eyes.

A full lower lip is indicated.

The chin is pointed.

The neck is thick.

Chibi Male

Hair does not fall below the ears.

The eyeballs are very tall, like ovals.

Bottom eyelids are thick and dark.

No lower lip is indicated.

Chin is rounded.

The neck is very thin, or eliminated entirely.

11

Drawing the Chibi Head Step-by-Step

Ready to dive right in? Good! Get your pencils out—we're going to start drawing chibis. Always start with a simple shape for the outline of the chibi head. Then, step-by-step, add the features. It's most important that you position the features in exactly the right spots on the face. In other words, space the eyes far enough apart, but not too far; place the nose down low on the face, but not too low, and so on. That's why we start with the crisscross guidelines that you see in the first step to ensure that the features are positioned correctly.

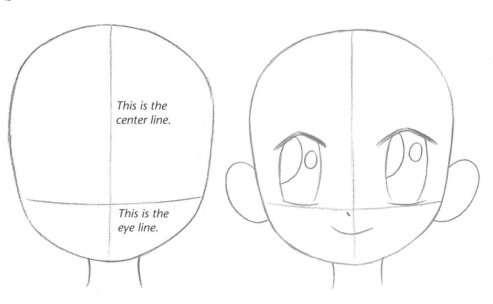

This is the center line.

This is the eye line.

Chibi Boy Head

The chibi boy is a cute, peppy character, fast-moving and energetic. Sure, chibis look sweet, but they are also famous for being funny troublemakers with combustible personalities.

Build up a lot of hair around the head.

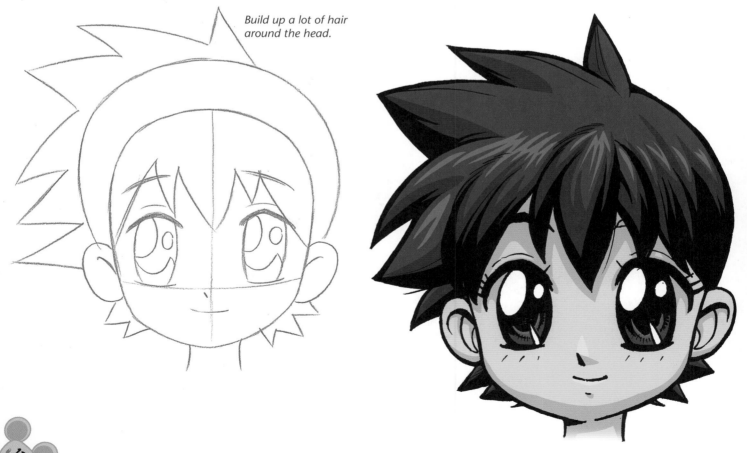

Chibi Girl Head

Because the eyes are bigger on chibis than on any other type of manga character, it's important to get them right. Let's focus on the eyes for just a moment. The upper eyelid is always drawn thick and dark. The eyelashes are, by contrast, lighter and thinner. The upper eyelid is drawn as a simple arch.

And now for the eye itself: First draw the eyeball. Then draw ovals inside of the eyes to indicate the shines. Next, draw the outline of the pupil area (as shown in step four), and then darken the pupil areas to finish. You can also add small, repeated lines around the pupil, in the whites of the eyes, to indicate the iris. The chibi girl can also have a few, very thin eyelashes that appear below the eyes, which "float," meaning that they are not attached to the lower eyelids.

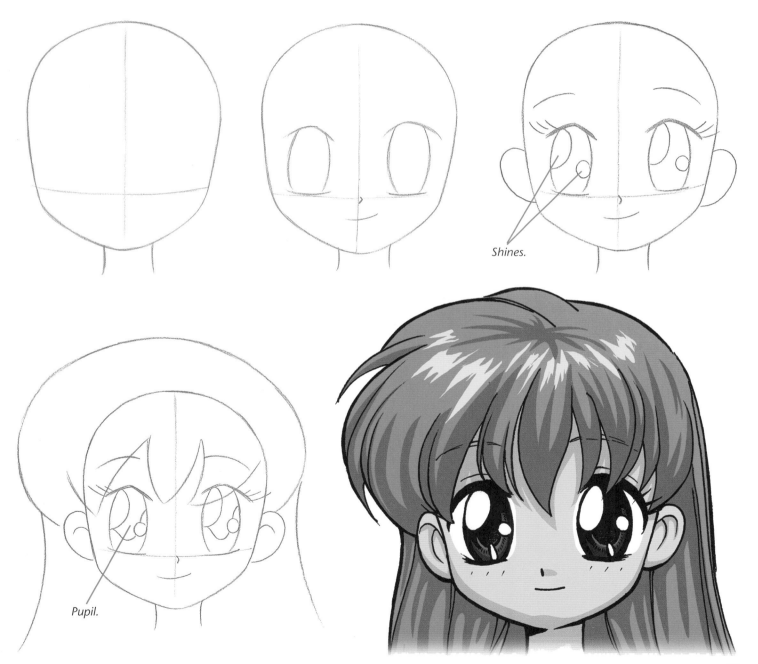

Shines.

Pupil.

13

Chibi Boy Side View

Side views, or "profiles," are sometimes challenging to draw, because of the in-and-out contours of the forehead, brow, bridge of the nose, lips, and chin. But on chibis, the outline of the face is simplified in order to create a cute look. As a result, a chibi profile is less complicated to draw.

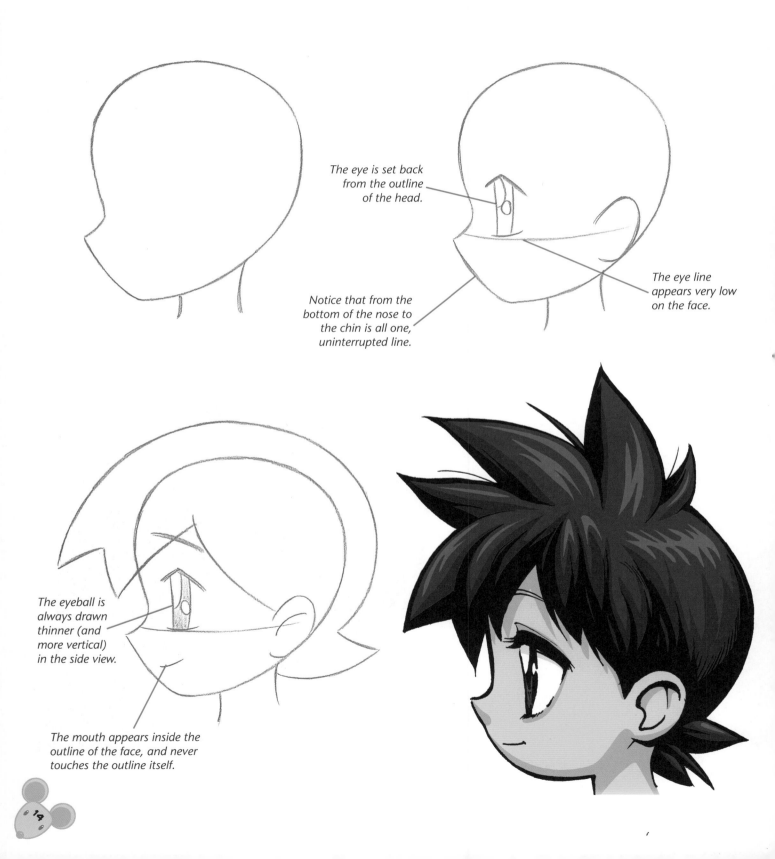

The eye is set back from the outline of the head.

Notice that from the bottom of the nose to the chin is all one, uninterrupted line.

The eye line appears very low on the face.

The eyeball is always drawn thinner (and more vertical) in the side view.

The mouth appears inside the outline of the face, and never touches the outline itself.

Chibi Girl Side View

Because these chibi characters are young, the outline of the girl's head is very similar to that of the boy's. (Boys' and girls' basic head shapes don't change radically until puberty.) The main difference is that the underside of the jaw is softer and fuller on the girl chibi. The girl chibi's eyes should be drawn with a few eyelashes on the top and bottom eyelids. The eyelids themselves are drawn slightly darker than the boy's, in order to bring out her femininity.

Most chibi girls wear long hair. (A general rule for artists is the younger the character, the longer the hair. Mature women usually wear shorter hair.) Long hair also has the effect of underscoring the diminutive size of the chibi by comparison. Long hair on a regular-sized teenager can reach down to the mid-back. On a chibi teen, it can almost touch the ground.

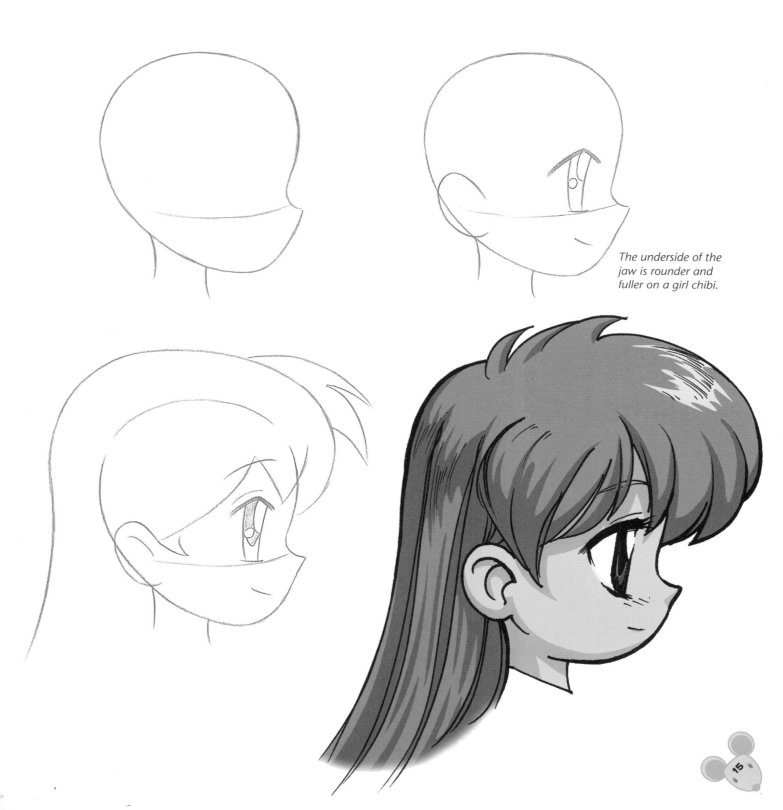

The underside of the jaw is rounder and fuller on a girl chibi.

15

Full Figures: Standard Manga versus Chibi

When you see a bunch of chibis together on a page, it's easy to forget how different their proportions are from regular manga characters. It's illustrative to see chibi and standard manga figures placed side-by-side.

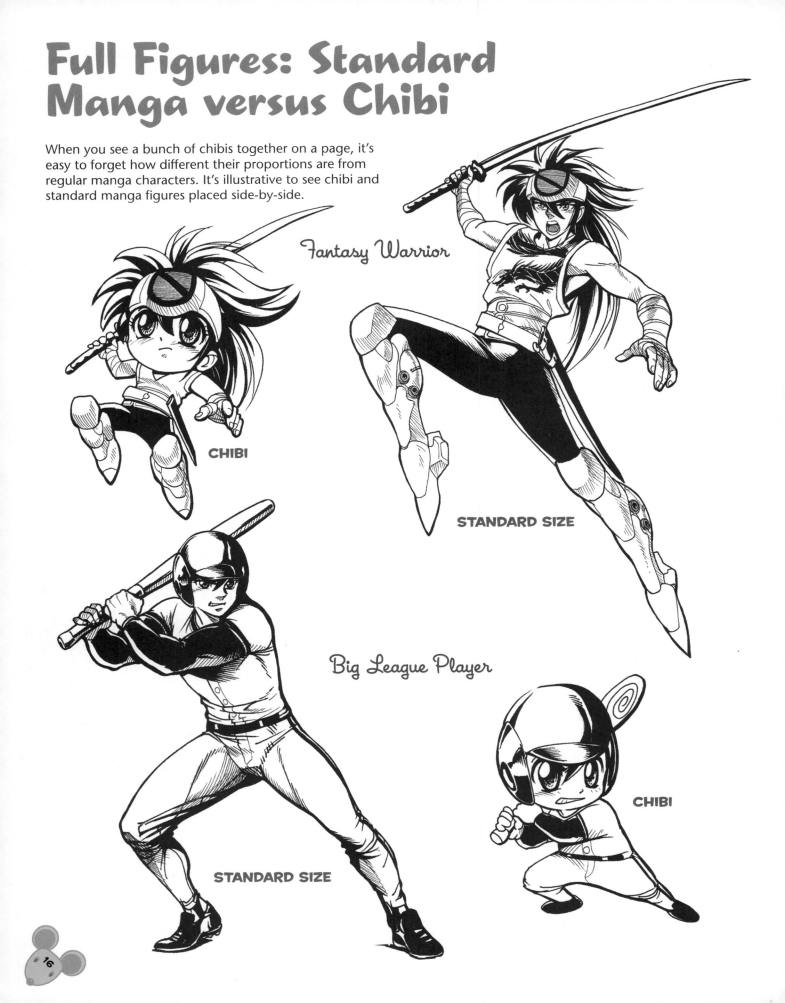

Fantasy Warrior

CHIBI

STANDARD SIZE

Big League Player

STANDARD SIZE

CHIBI

Turn Any Character into a Chibi!

If you can draw it as a person, you can draw it as a chibi. Because the arms, legs, and torso of chibi characters are so truncated, the poses have to be simplified. With such chunky physiques, they can't do lots of complicated moves—nor would you want them to. Yet, surprisingly, due to their outgoing personalities, chibis are great at communicating emotions and attitudes.

School Girl

Rebellious Youth

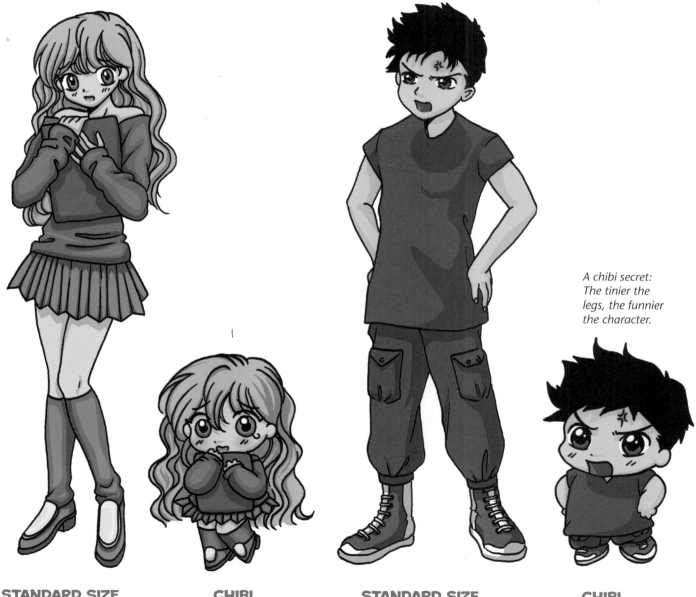

A chibi secret: The tinier the legs, the funnier the character.

STANDARD SIZE　　**CHIBI**　　　**STANDARD SIZE**　　**CHIBI**

Personality Pointers

A chibi's personality is conveyed through his or her facial expressions, humorously clumsy body language, and oversized costuming. The clothes often look big on chibis, as if they were borrowed from an older sibling.

Expressions are broad on chibis—broader than they are on standard manga characters. Another way to think of chibis is as caricatures of regular comic characters, or even as miniature versions of them.

Crazy Inventor

Clueless Teen

A Note About Adjusting Costumes

As you "shrink" your character down to chibi size, adjust the costume so that it doesn't become too busy. For example, the number of buttons on the crazy inventor's lab coat has been reduced from five to two. There may not be any lab coats with only two buttons, but you have to sacrifice some realism in order to convey a concise, visual idea.

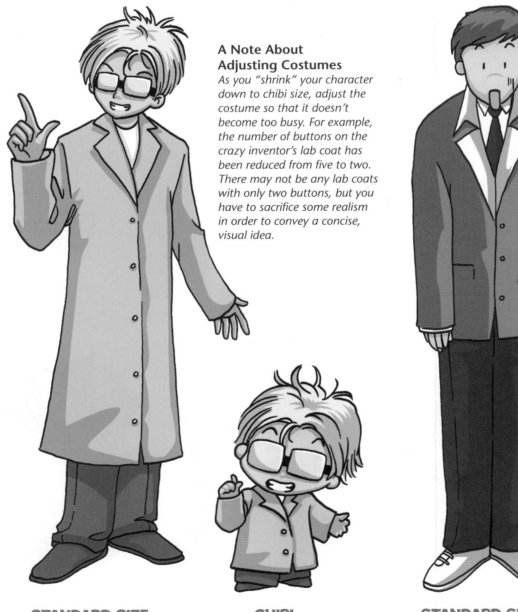

The mouth on the chibi is even larger than the mouth on his regular-sized counterpart.

STANDARD SIZE **CHIBI** **STANDARD SIZE** **CHIBI**

Ditzy Girl

Tough Guy

The tattoo on the chibi takes up half of his arm, whereas it only takes up a small proportion of the regular-size boy's arm. But if you were to reduce the tattoo on the chibi, the tattoo would be so small that the reader wouldn't be able to make it out.

There are some elements of a character that should not be reduced at all. The hair is a good example. The girl's ponytails have not shrunk at all! The contrast makes her look very small and silly.

It's hard to keep a tough guy looking tough when he's a chibi—but why would you want to? Look at the dude in the leather vest. Now look at his chibi counterpart. Which one is more fun?

STANDARD SIZE **CHIBI** **STANDARD SIZE** **CHIBI**

The Chibi Size Chart

As people grow, their proportions change. A baby's head is much bigger, relative to the size of its body, than the head of a grown man. But here's an interesting fact about chibis: No matter what age your chibi character is, no matter what his height, he always has the same proportions, that is, two- to three-heads tall. That goes for toddlers, kids, tweens, teens, and adult chibis. However, the hairstyle, expression, and clothing (fashions) can all change to reflect the different ages of chibi characters. Let's look at how different ages are depicted in standard manga characters, versus how they are depicted in chibi characters.

DRAWING TIP

There may be some situations where you elect to invent a series of larger chibis, for example, three-heads tall. But then the same principles would apply: All of the chibis in that series, no matter the age or height, would still be three-heads tall.

Little Kid

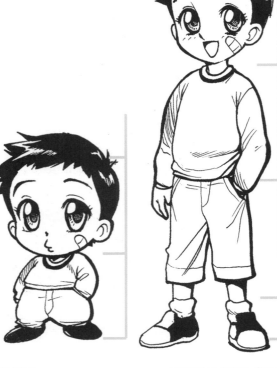

Tween

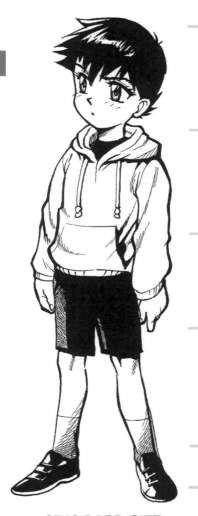

CHIBI
No matter what his age is, the chibi always remains a little over two-heads tall.

STANDARD SIZE
A regular-size manga kid is a little over three-heads tall.

CHIBI
Even though he's taller than the little kid chibi, the tween chibi has the same proportions: A little over two-heads tall.

STANDARD SIZE
As the regular tween boy grows taller, his proportions change. He's now a little over four-heads tall.

Teenager

Adult

CHIBI
The teenage chibi can't get any taller than the tween chibi, otherwise, he'll be too big. So his growth spurt stops there, and he retains the same proportions as all the other chibis: a little over two-heads tall.

STANDARD SIZE
Meanwhile, the regular teenage boy has grown taller, and his proportions have changed as well. He's now stretched out to six-heads tall.

CHIBI
The chibi adult is still just a bit over two-heads tall.

STANDARD SIZE
The regular adult character is fully grown at seven-heads tall.

21

Drawing the Chibi Face and Body Step-by-Step

Now that we've reviewed the basics, let's dive in with both feet. I've simplified the drawing process with these easy-to-follow steps. Even though they appear simple to copy, the real task is in making sure that the chibis communicate a cute and "squeezable" quality. That means a narrow chest, a protruding tummy, little feet and hands, and a tiny neck, or no neck at all!

Chibi Girl

The eyeline is very low on chibis!

Start with a cute, round body.

You're already aware that the head is very big on a chibi, but are you also aware that the head is actually wider than the body?

Tiny hands!

The legs are thick, never skinny.

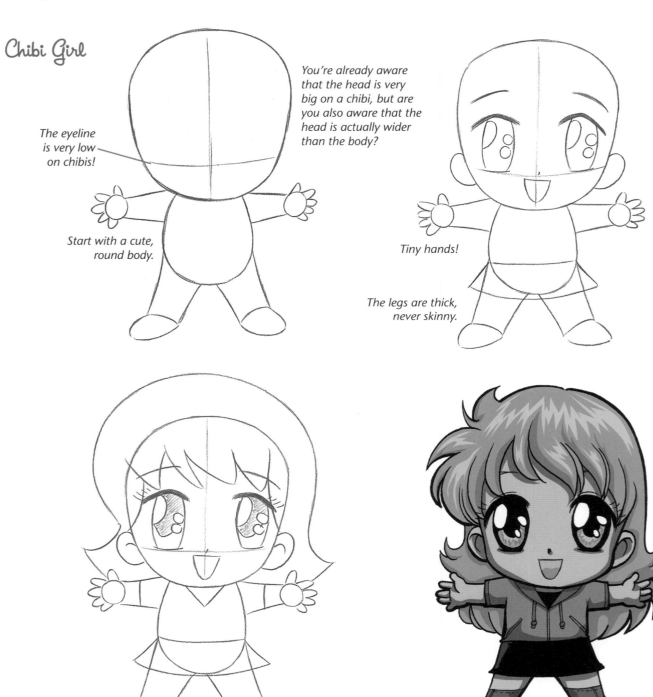

Chibi Boy

After you've finished step three, you might want to have a clean, finished drawing. But it can be difficult to erase the unwanted guidelines while keeping the rest of the pencil lines intact. One way to avoid this problem is to trace over your drawing, leaving out the guidelines. This can sometimes require a lightbox, but more often you can see through the paper enough to do a decent tracing. You could also use tracing paper, or a higher-quality tracing paper called "vellum," to transfer the drawing. Vellum is the type of tracing paper used by professional comic artists.

To create a clean inked drawing, draw directly over the pencil lines (leaving out the guidelines, of course), and then allow the ink to dry completely. Once the inked drawing is dry, erase over the entire image. (Choose an ink that is age-appropriate. There are non-toxic inks available. Check the labels.) The pitfall of this inking method is that if you mess up, you will have ruined your original drawing. So you might want to ink over the drawing on vellum, to preserve the original.

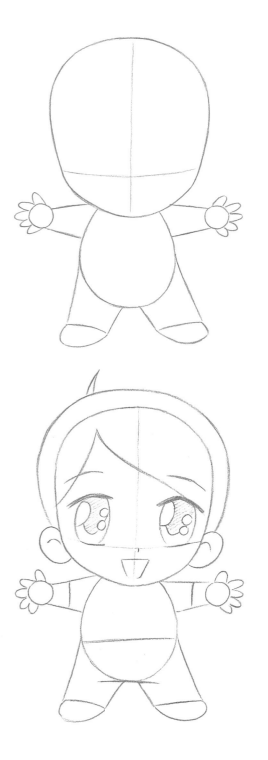

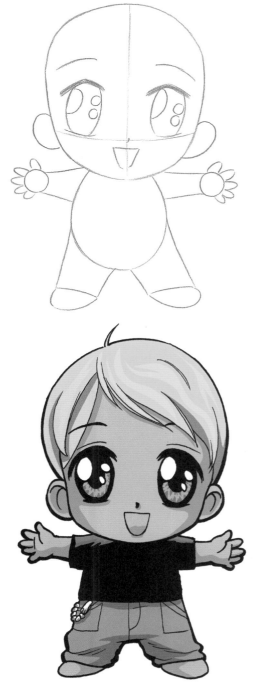

Full-Body Side Views

You can really see that little tummy sticking out on the full-body side view. It is created by the curve in the small of the back: The chibi girl's tummy isn't fat, it's being pushed out by her posture, which is youthful. If her back were straight, her tummy would flatten, and the pose would look lifeless.

Chibi Girl

The torso is shaped like a kidney bean.

The curve of the back makes the tummy push out.

Big head and small body are the classic chibi proportions.

Note that the mouth, even when opened, remains inside the closed outline of the head.

Note how the entire front of her torso is curved. That's an essential ingredient for all cute characters.

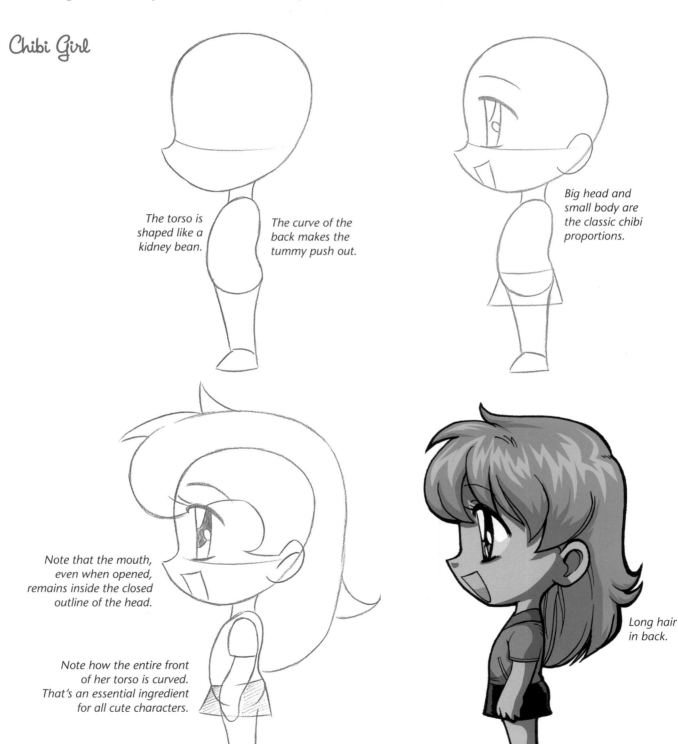

Long hair in back.

Chibi Boy

The chibi boy has the same basic body shape as the chibi girl in the side view—the kidney bean torso—but his shoulders can be drawn slightly thicker. He gets his "boy" look more from his face, hairstyle, and clothing than from his basic body construction.

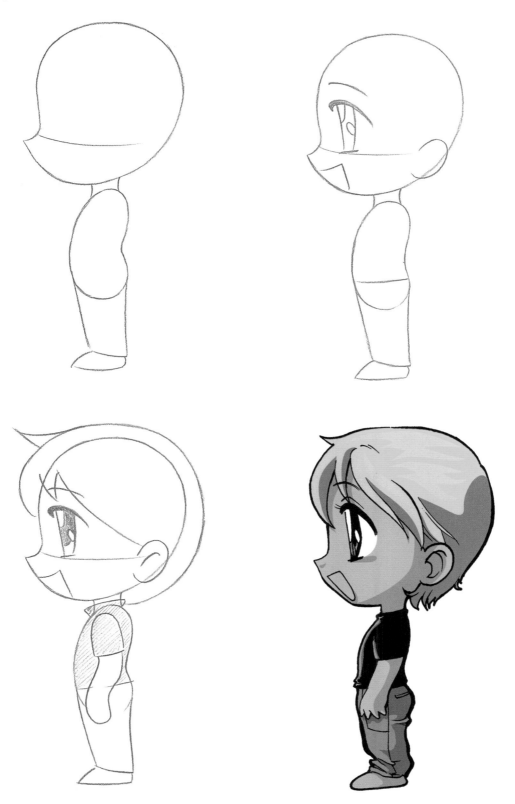

CHIBI CHARACTERS AND COSTUMES

Chibi characters range from miniature huggables and devils to furry characters and monsters. They come in all varieties and roles, including chibi teenagers, fairies, schoolgirls, nurses, mermaids, devils, angels, and everything in between! In this section, we're going to see how clothes and costumes are the magic ingredient that creates a character's identity. I will also introduce you to a variety of chibi character types.

Costumes

You can draw a boy on a skateboard in trousers and a button-down shirt, but to really carve out his identity you will have to go further. For example, try giving him a backward-facing cap, a sweatshirt, and a backpack. Always draw the latest trends. Also keep in mind layering, which means wearing one piece of clothing on top of another, such as a scarf, vest, and jacket. Layering is a great way to get more style into a single outfit.

Curls go with ruffles!

Note the line connecting each ruffle.

Bubbly Personalities

Chibis are active folk, always busy doing things. Even when they're just standing, they should look ready to go. Chibis are best drawn with a positive posture: head held high, back arched (unless they are experiencing an extreme emotion, such as sadness). They rarely bend much at the waist, because their truncated bodies don't allow for much twisting and bending. Also, a spritely personality translates into a straight spine.

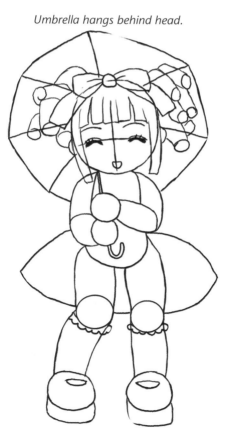

Umbrella hangs behind head.

Thick, chunky soles.

Mischievous Chibis!

Not all chibis are good. But even the bad ones aren't *that* bad. While both male and female chibis are usually drawn with the physiques of children, female chibi characters can also be drawn with a more mature build that emphasizes curves.

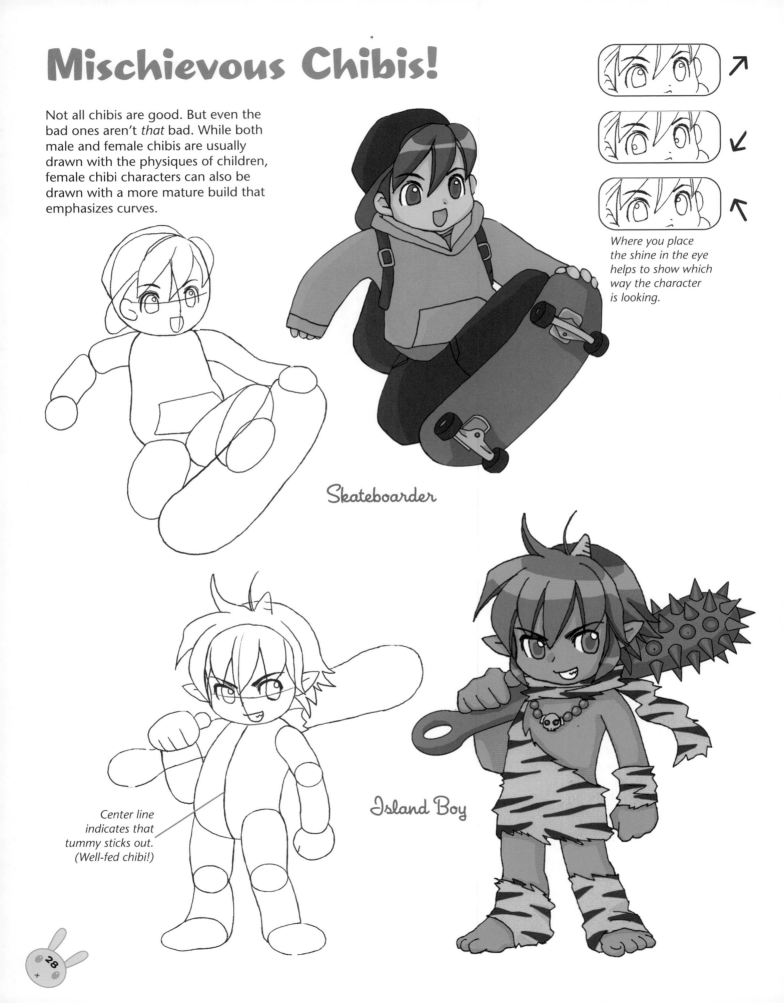

Where you place the shine in the eye helps to show which way the character is looking.

Skateboarder

Center line indicates that tummy sticks out. (Well-fed chibi!)

Island Boy

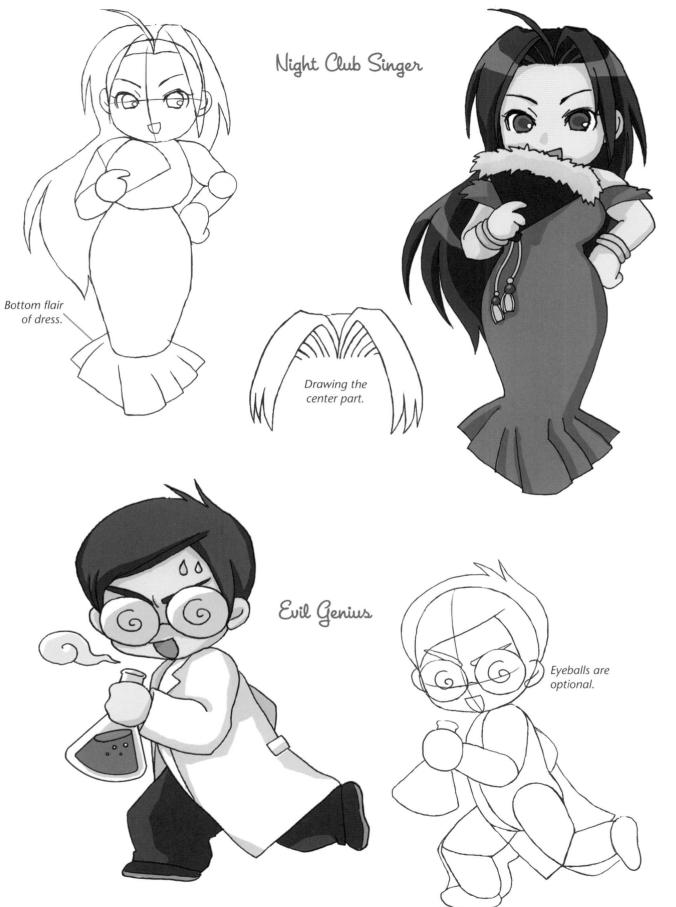

Night Club Singer

Bottom flair of dress.

Drawing the center part.

Evil Genius

Eyeballs are optional.

Making Eye Contact

With regular manga characters, you should avoid having the character look directly at the reader, as it breaks the reality of the comic story. However, chibis are so disarming and engaging that readers love to have chibis look directly at them, wink, or give them the "thumb's up" sign.

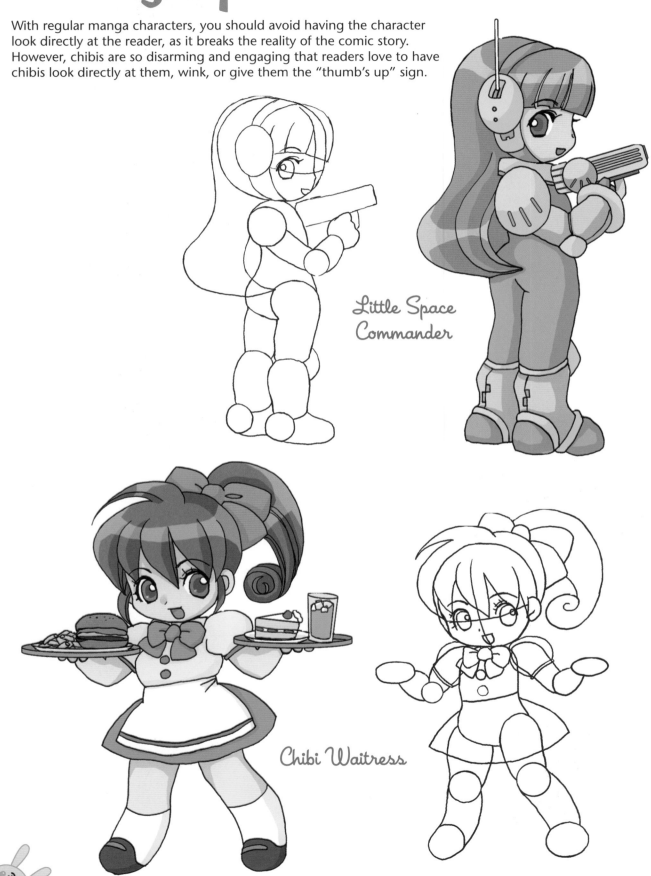

Little Space Commander

Chibi Waitress

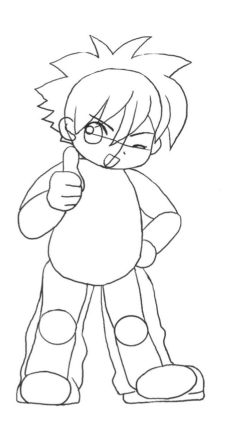

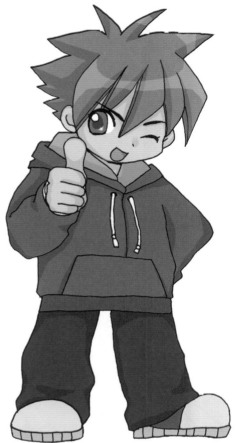

Chibi Schoolboy

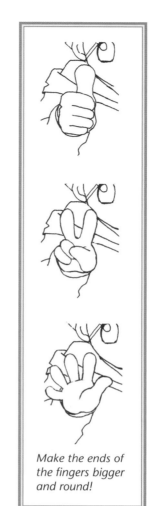

Make the ends of the fingers bigger and round!

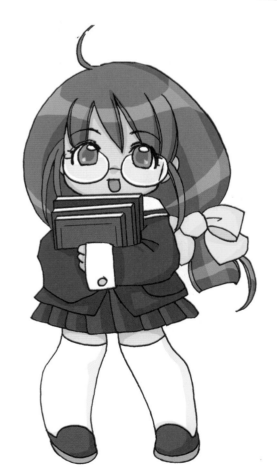

Chibi Schoolgirl

Girl Costumes and Popular Japanese Roles

Costumes and outfits should quickly identify the occupation of the chibi. Be sure to add all of the accessories that are pertinent to the chibi's job. The more authentic the outfit, the cuter the chibi will be.

Maids

Maids are popular characters in Japanese comics. While today's residential housekeepers rarely wear uniforms, maids in manga always do. They wear them as a sign of their profession, like a housekeeper at a five-star hotel. The apron and headdress are important to finish the look.

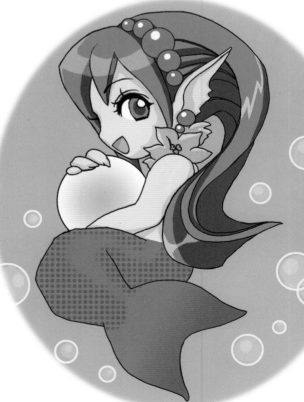

Nurses

Nurses, too, are popular character types in Japanese comics, and they are good role models—they symbolize comfort and caring. Although it is a simple design, the nurse's cap has a distinctive shape, unlike any other, so it's essential that every chibi nurse character wear it.

Mermaids

Not just a tail, but an elfin ear is required for every good chibi mermaid. In addition, mermaids are always drawn with long, flowing hair. And don't forget the pearls!

Genies

Genies and magical characters of all sorts
are popular in manga. The genie's head should have sharply angled eyebrows, for a semi-devilish look, and pointed ears. Exotic jewelry, like this forehead bracelet, makes her look enchanted. Billowing

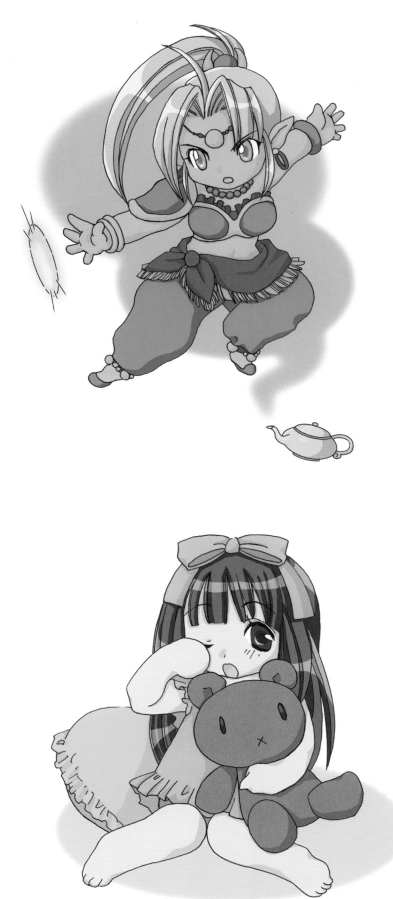

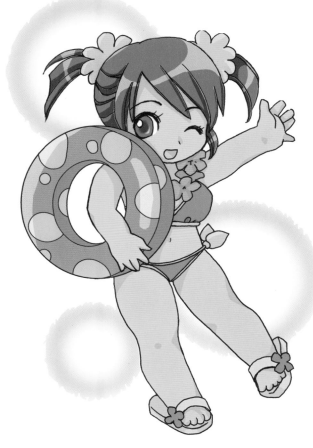

Beach Party!

Fun in the sun! This chibi is ready for some splish-splashing. Remember to keep the chibi body plump, even in beach clothes.

Good Morning

It's always good to capture a chibi in an innocent moment, which makes them look sweet and spontaneous. This little chibi has just woken up—well, maybe not quite yet! The balled up fist, rubbing a closed eye, is a classic look for a tired chibi.

Stupid Chibis!

Chibis are some of the funniest characters in all of manga. The denser and more immature, the funnier. These thickheaded chibis are fun types that we've all seen one place or another.

Stars mean he's down for the count.

Note the bubbles, which indicate bunches of tears percolating up during a temper tantrum.

He Fall Down, Go Boom

Things Not Going Her Way

Underachiever

This kid has to struggle to pass his lunch period.

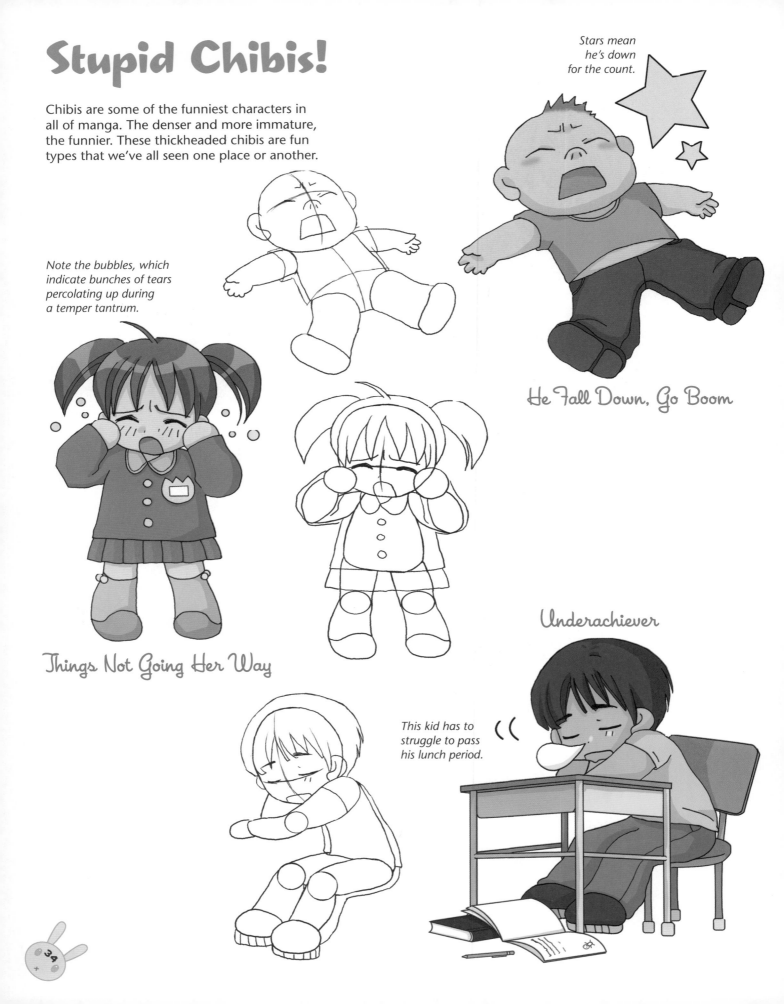

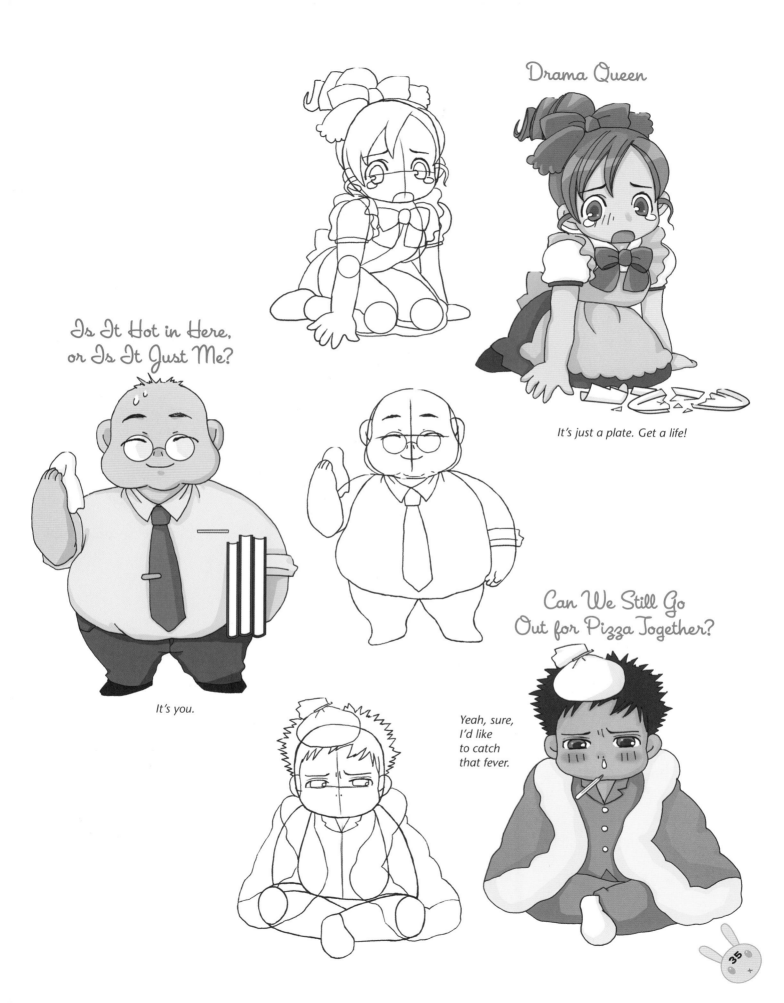

Drama Queen

Is It Hot in Here,
or Is It Just Me?

It's just a plate. Get a life!

It's you.

Can We Still Go
Out for Pizza Together?

*Yeah, sure,
I'd like
to catch
that fever.*

35

Regular Chibis versus Super-Small Chibis

Super-small chibis are even smaller than regular chibis. They are only two-heads tall, or even less. Super-small chibis are great to use as decorations in the margins of comic book pages. To transform a regular chibi into a super-small chibi you will need to simplify the chibi's hair, clothes, and even hands.

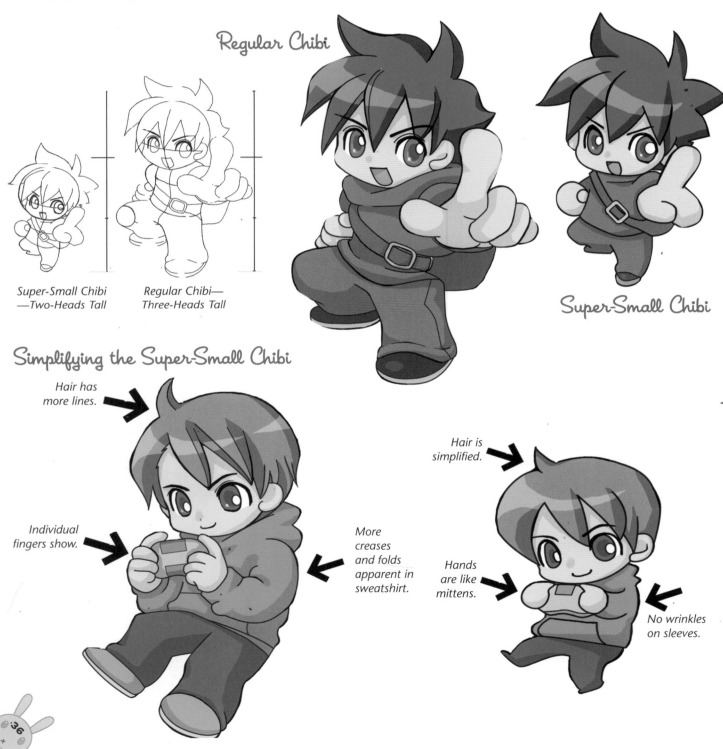

Regular Chibi

Super-Small Chibi

Super-Small Chibi
—Two-Heads Tall

Regular Chibi—
Three-Heads Tall

Simplifying the Super-Small Chibi

Hair has more lines.

Individual fingers show.

More creases and folds apparent in sweatshirt.

Hair is simplified.

Hands are like mittens.

No wrinkles on sleeves.

Super-Small Chibi Girl

It's hard to believe that a chibi could get any cuter, but the super-small chibi can! It's important to notice that not *everything* gets smaller as the chibi shrinks to two-heads tall. The props (pompoms) and the ribbon in her hair *stay the same size as before.* This contrast underscores the smallness of her size. Otherwise, it might look as if we just reduced the image of the regular chibi, instead of adjusting the proportions. (Likewise, on the previous page, note how the boy's camera stays the same size in both style chibis.)

Regular Chibi

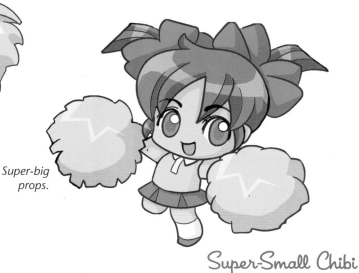

Super-big props.

Super-Small Chibi

The props are the mouse, the cat ears, and the boxing gloves. They retain their original size on the super-small chibi, which makes the character look even smaller by contrast.

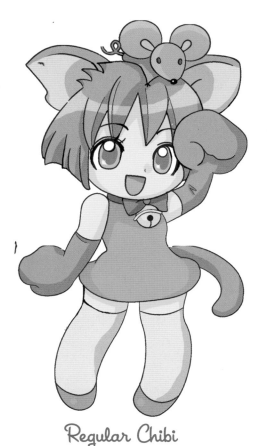

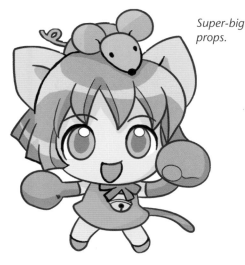

Super-big props.

Regular Chibi

Super-Small Chibi

Fantasy Chibis: Angels, Fairies, and Princesses

Chibis make great fantasy characters because of their cherubic proportions. These enchanted chibis are perfect types to cast as friends and magical mentors. Don't try to do too much with any given pose; remember that their compact size prevents chibis from appearing limber.

Nature Fairy

Her outfit is cut to look as if it came from a leaf.

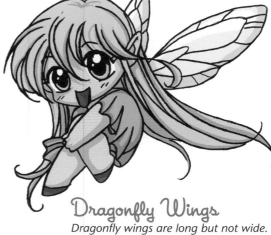

Baby Fairy

Butterfly wings! Younger fairies are often shown with baby antennae, which they outgrow when they get older. (Note the pajamas.)

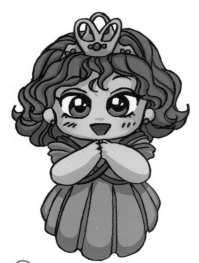

Princess

A tiara, of course—every princess has one! Both of my daughters did, although theirs came from the toy store.

Angel

Feather-style wings and a halo.

Dragonfly Wings

Dragonfly wings are long but not wide. They are also translucent (meaning that light shows partially through them, but they are not completely see-through), with arteries weaving through them in decorative patterns.

Enchanted Girl

The dreamy eyes and wavy hair give her a bewitching look.

Spying Type

This type of fairy pokes around in everyone's business, listening in on conversations and spreading gossip. His outfit comes straight out of mythology: a toga slung over one shoulder plus high-strap sandals.

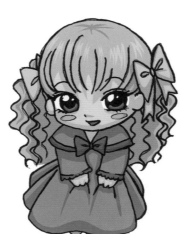

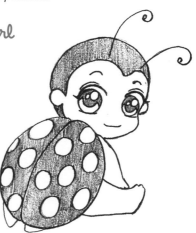

Lady Bug

She's a cute little bug with a big face and a sweet smile.

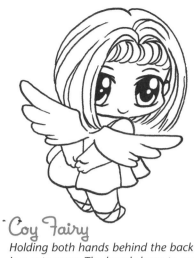

Coy Fairy

Holding both hands behind the back is a cute pose. The hands have to go under the wings, or she won't be able to flap them. Instead, she'll fall, hurt herself, get an enchanted attorney, sue, and put the entire fairy kingdom out of business.

Freckled Fairy

Kind of the "tomboy" of fairies.

Magical Princess

A billowing gown gives the wearer a magical quality.

Traditional Princess

A traditional chibi princess wears a kimono, of course!

Flower Petal Fairy

See how the petals are drawn individually, and fan out around the waist to form a skirt? They also dip at the ends, because flower petals are flexible.

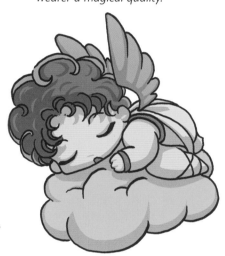

Sleepy Angel

Clouds make the perfect mattress. But you're still not allowed to tear the tag off.

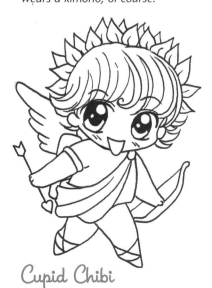

Cupid Chibi

A wreath of leaves gives him that "out of the woods" look.

Fairy Godmother

The chibi fairy godmother packs a lot of power in a small package.

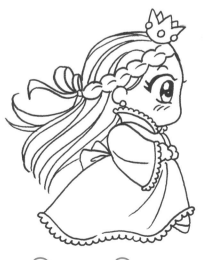

Runaway Princess

Guess this little chibi didn't go for the looks of her groom!

Chibi Expressions, Emotions, and Attitudes

A chibi with an attitude is a funny thing. Some chibis are happy, others are grumpy, and some are furious! And each can fluctuate rapidly between these moods, infusing a scene with a lot of energy and humor. Just because they're small doesn't mean that they don't have BIG expressions, or even bigger reactions. In fact, chibi reactions are so over-the-top that they are downright hilarious! They react on a much, much bigger scale than regular full-sized characters. All that emotion coming from such a tiny container!

Emotions

A chibi's emotions are easy to read—just look at the facial expressions. Everything is so over the top, it's as plain as the nose on their face, er, I mean, if they had a nose. Let's compare the standard expressions of regular-size manga characters with their chibi counterparts. You'll see that the chibi face is distorted and elastic—stretching way past the breaking point, but never breaking. The key to chibi expressions is to make them big, broad, and highly exaggerated.

Happy

STANDARD MANGA

CHIBI

The chibi's mouth falls below the line of the chin. A physical impossibility, but a popular technique nonetheless.

Pucker

STANDARD MANGA

CHIBI

When puckering, the chibi lips suddenly get huge.

Silly

STANDARD MANGA

CHIBI

Feeling silly, the chibi mouth gets big and the tongue gets giant.

Anger

STANDARD MANGA

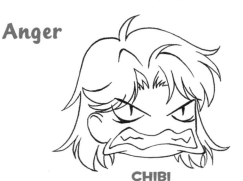

CHIBI

The angry face stretches wide—way wide. The pupils get teeny and cat-like.

Sad

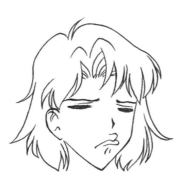

STANDARD MANGA

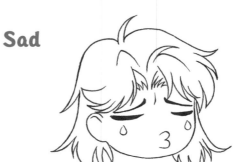

CHIBI

Chibi sad = big lips, big tears..

Fury

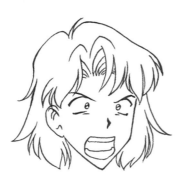

STANDARD MANGA

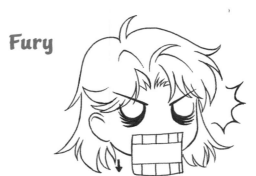

CHIBI

In fury, tremendous dark circles suddenly appear under the eyes, which in turn grow white with rage. Teeth show, and the mouth drops below the face.

Annoyed

STANDARD MANGA

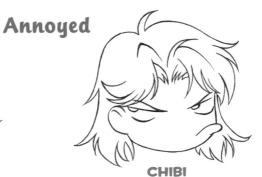

CHIBI

When annoyed, the chibi mouth is pushed way to one side. The pupils become little beads of white.

Tired

STANDARD MANGA

CHIBI

Don't forget the all-important drool!

Yucky!

 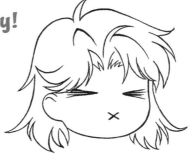

STANDARD MANGA **CHIBI**

An "X" gives her that "sour lemon" face.

Pleased

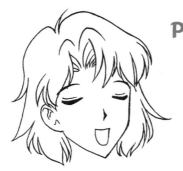 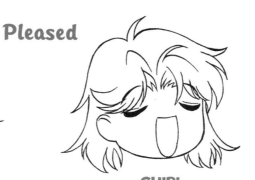

STANDARD MANGA **CHIBI**

A super-tall mouth gives her an air of satisfaction.

Stunned

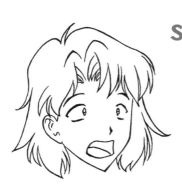 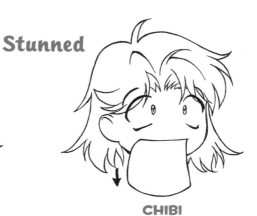

STANDARD MANGA **CHIBI**

Draw an extremely wide mouth (with its interior left blank) to show extreme surprise. The mouth should be almost falling off the face.

Cheerful

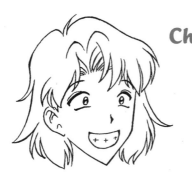 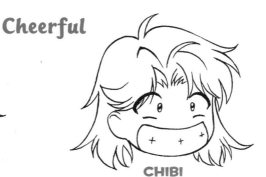

STANDARD MANGA **CHIBI**

Chibis have a very wide, toothy smile. The lower lip and the chin share the same line.

Body Language with Special Effects

Body language with special effects is often used to enhance the expression of a chibi character. Yes, I know that it's not much of a body. In fact, on a typical chibi character, there's very little body to speak of! Therefore, special effects are particularly useful in helping to define an attitude. These pages demonstrate some of the more popular, uniquely Japanese uses of such humorous body language and special effects.

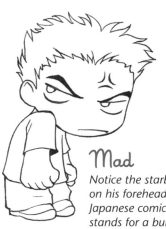

Mad

Notice the starburst on his forehead. In Japanese comics, that stands for a bulging blood vessel, a good indication that someone is real mad.

Gulp!

In fear, the chibi body freezes with the arms extended. Notice the extra-wide mouth, pulled way low on the face.

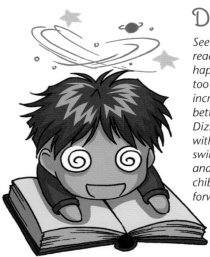

Dizzy

See what happens when you read too much? This never happens from watching too much television. So, increase your TV viewing for better health. (Just kidding!) Dizzy characters are drawn with spirals in their eyes, and a swirling bunch of mini-stars and planets overhead. This chibi is so dizzy he leans forward, collapsing.

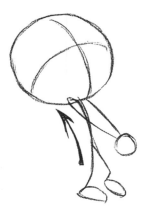 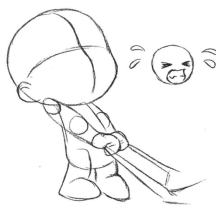

Crying

To show a chibi crying, draw eyes that look all wobbly with water, with streams of tears cascading down the cheeks.

Effort

The Line of Action in the first step diagram of this character shows that the body is leaning back. It won't work if it doesn't have that "lean," no matter how many sweat marks you put around her.

44

Hypnotized

This pose also works to show someone hypnotized, as if in a trance or under a spell. Eye swirls with a floating body posture.

Bright Idea!

A snap of the fingers, one hand on the hips, a wink and a smile—now that's a brain cooking up a good thought!

Wishful

Multiple stars in the eyes indicate wishful thinking.

Sleepy

Add the letter "Z" a bunch of times. Her mouth should form a little "O."

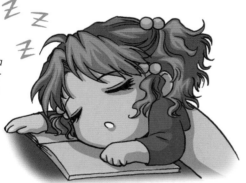

Hilarity

Note how the laughter lines fan out around the character's head. The head of a laughing character always tilts up. He hugs his belly, which tickles so much it hurts.

Blush

Sketch blush lines going across the face. The body language should be introverted, with hands close together, as if the chibi is nervous.

Oh No!

Here the eyes go wide, but the pupils become small beads. Drop the mouth way down low on the face.

Choke

More squishy, wet, slimy eyeballs. Get a grip, and a tissue!

Magical Effects

Magical effects are a humorous way to visually reflect what is going on inside of a character's mind. These effects are great, but don't use them too often on a single page, or they'll lose their novelty. And one word of warning: Don't be tempted to let the magical effects do all of the work for you—your character's personality is still the driving force in conveying his or her intentions to the reader.

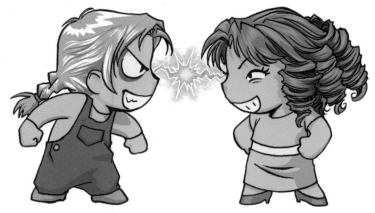

Conflicting Intentions

A bolt of electricity that clashes in the middle.

Surprise Lines

Surprise lines always radiate outward from the center. Draw a dot lightly, in pencil, in the middle of the picture (where the boy's nose would be) and make sure all the lines emanate from that point. Once you've finished the picture, erase the pencil dot.

Serenity

Fantasy air-bubbles, flowers, and mini-starbursts.

The Big Stretch

Talk about distorting a character's face for an expression! This one really pushes the limits, but it works because it's done for humorous effect. Note the repeated fists of the little girl. This is how you indicate flailing arms in Japanese comics.

Scheming Thought

Evil thoughts take place not just inside a character's head, but also swirl around her.

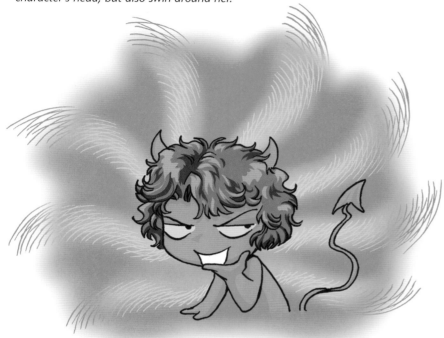

SNEAK
SNEAK

Sneaky

Chibi eyes can take on the shape of special effects (starbursts), and then resume their normal shape when the moment is over.

Yikes!

Easy on that tabasco, little fella!

HOT

Questionable Little Angel

She's really putting it on, isn't she? The "shine lines" around the halo give it a funny look, which matches her sheepish expression.

Tears of Joy

A pair of rivers run down her cheeks, and sparkles appear all around her.

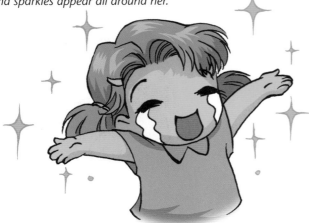

Rage

A raging electric storm in the brain becomes visible outside of the head. Note the popping blood vessel in the tightly fisted hand.

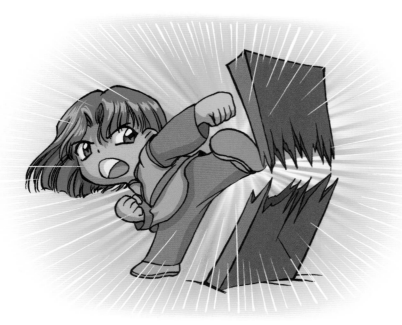

Action Lines

Less directional than "speed lines," which are lines that trail an object moving through space, "action lines" are part of the background and dramatize the overall feeling of action in a scene. Be careful not to allow the action lines to significantly overlap the character.

Daydreaming

An overhead visual pops into her head. It always appears above the character.

Caught in the Act!

Now the spotlight is really on her.

Love Struck

Men, run for the hills!

Hurt Stars

Stars with squiggly lines emanating from the boo-boo.

A Real Gusher

Next time, maybe you should just let her have her way.

Fatigue

He's running on fumes, which are shown as little wisps of smoke above him.

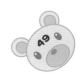

Chibi Cat-Girls and Furry Characters

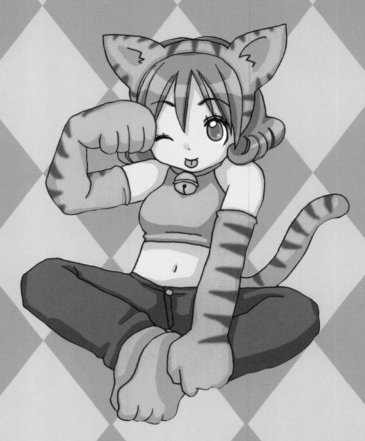

Here's a good place to introduce a very famous and wildly popular Japanese character type: furry characters. Furry characters are most often based on cats, but can take on other forms, such as rabbits, mice, and even bears. The cat-girl characters are stars in their own right, appearing in lots of manga as both chibis and regular-size characters. This chapter, will reveal the secrets of how to draw chibi-size cat-girls and other furry characters.

Furry-Style Ears

The first step to creating a furry character out of a chibi is to add furry-style ears. Furry ears are placed on the head like animal ears, at a 45-degree angle. The hair should cover the origin of the ears. While you can make a furry-type character based on any mammal, the following are the most widely seen in comics.

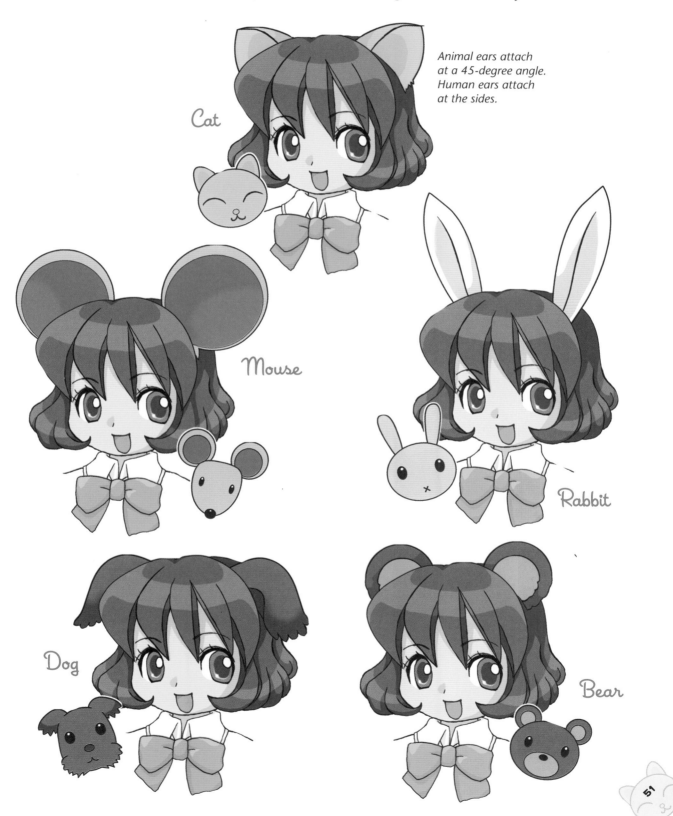

Cat

Animal ears attach at a 45-degree angle. Human ears attach at the sides.

Mouse

Rabbit

Dog

Bear

Chibi Cat-Girls: Full Figures

Chibi cat-girls are the simplest types of cat-girls. Regular-size cat-girls can get more complicated, adding cat noses and cat-like mouths, as well as fur, whiskers, and more. But chibis are simple characters, and, therefore, our rule about them still stands: simplify!

Chibi Cat-Girl with No Tail

In its simplest form, a chibi cat-girl has cat ears and no tail. Notice that cat ears point out at a 45-degree angle. You should also notice that cat ears are usually drawn so that we can see most of the interior of the ear.

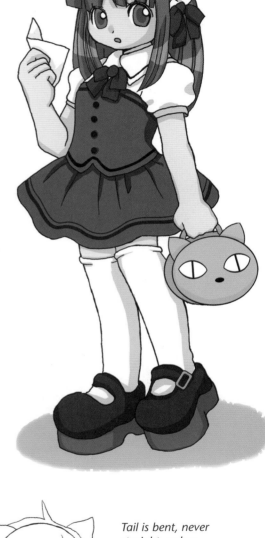

Ears point out at 45-degree angle.

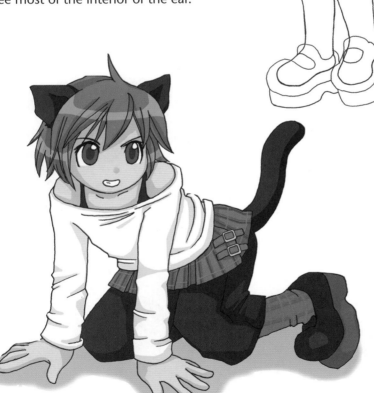

Chibi Cat-Girl with Tail

The most common type of cat-girl character has cat ears as well as a tail. Note how the cat-girl chibi takes on a cat-like pose and attitude. We'll learn more about this important aspect of cat-girl behavior when we get to the chapter on regular-size cat girls.

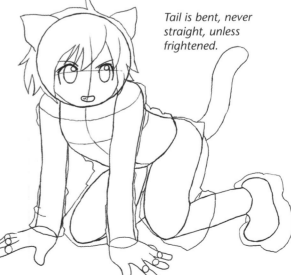

Tail is bent, never straight, unless frightened.

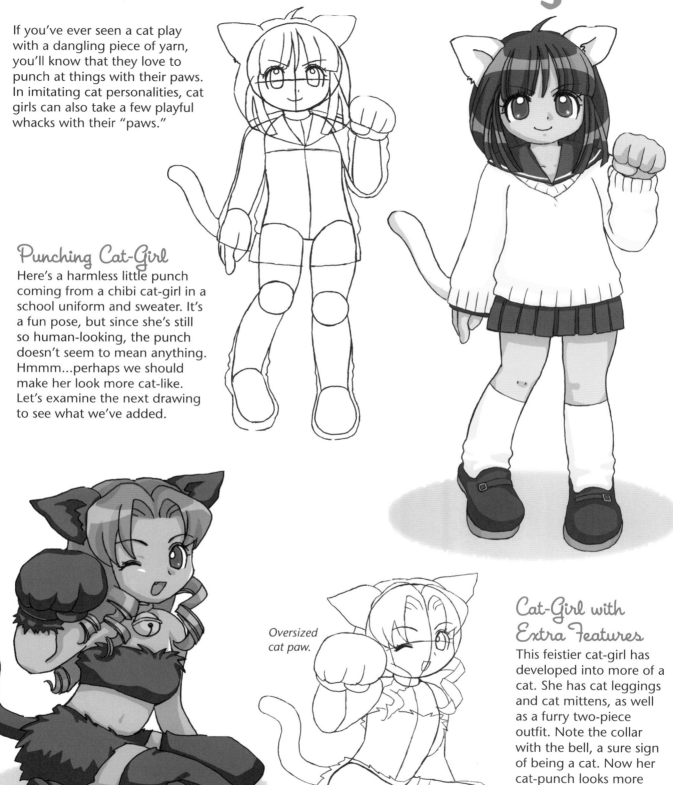

If you've ever seen a cat play with a dangling piece of yarn, you'll know that they love to punch at things with their paws. In imitating cat personalities, cat girls can also take a few playful whacks with their "paws."

Punching Cat-Girl

Here's a harmless little punch coming from a chibi cat-girl in a school uniform and sweater. It's a fun pose, but since she's still so human-looking, the punch doesn't seem to mean anything. Hmmm...perhaps we should make her look more cat-like. Let's examine the next drawing to see what we've added.

Oversized cat paw.

Cat-Girl with Extra Features

This feistier cat-girl has developed into more of a cat. She has cat leggings and cat mittens, as well as a furry two-piece outfit. Note the collar with the bell, a sure sign of being a cat. Now her cat-punch looks more authentic, because she clearly has more cat traits and possesses a more cat-like personality.

53

Chibi Cat-Girl Types

When drawing chibi-style cat-girls, remember that what you're really drawing are "kitten-girls." The breed is up to you: tabby, calico, fluffy, or a mix.

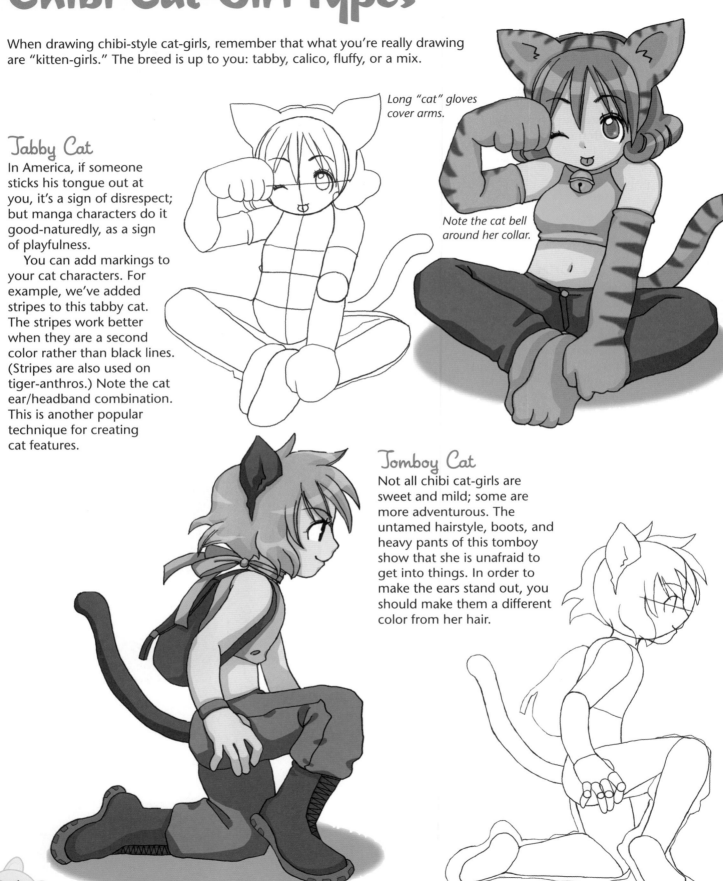

Tabby Cat

In America, if someone sticks his tongue out at you, it's a sign of disrespect; but manga characters do it good-naturedly, as a sign of playfulness.

You can add markings to your cat characters. For example, we've added stripes to this tabby cat. The stripes work better when they are a second color rather than black lines. (Stripes are also used on tiger-anthros.) Note the cat ear/headband combination. This is another popular technique for creating cat features.

Long "cat" gloves cover arms.

Note the cat bell around her collar.

Tomboy Cat

Not all chibi cat-girls are sweet and mild; some are more adventurous. The untamed hairstyle, boots, and heavy pants of this tomboy show that she is unafraid to get into things. In order to make the ears stand out, you should make them a different color from her hair.

In-Space Adventures

Just when you thought we couldn't possibly come up with one more genre for chibi characters, here come the sci-fi chibi cat-girls from outer space! Chibis are incredibly versatile characters. Since chibis are generally cute and sweet, you wouldn't want to draw them wearing battle-worn armored suits, like the type worn in hard-core sci-fi action comics. Instead, make their suits tailored to fit, with rounded shoulder and knee guards. Avoid sharp angles and weapons systems.

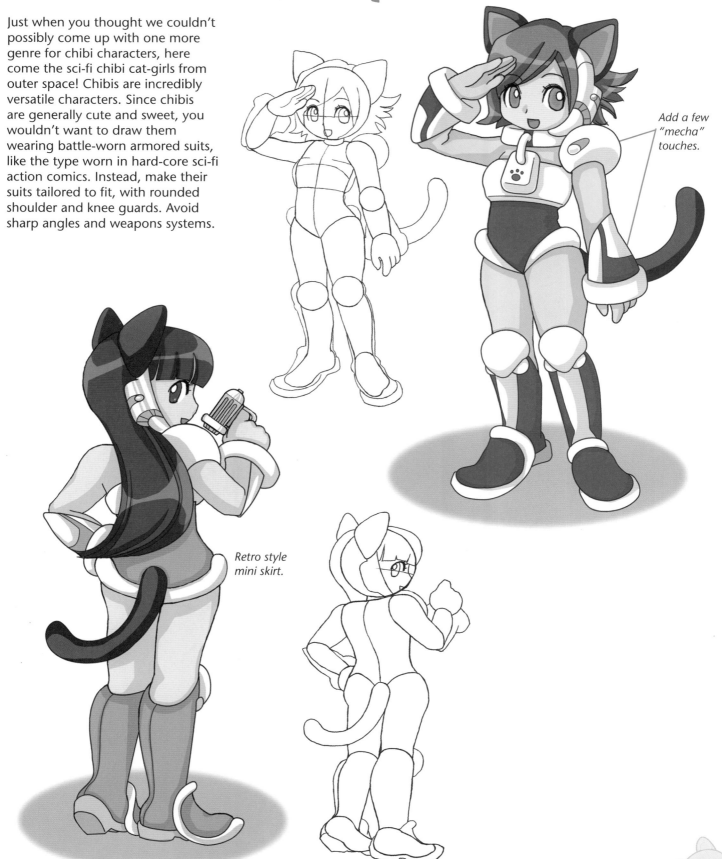

Add a few "mecha" touches.

Retro style mini skirt.

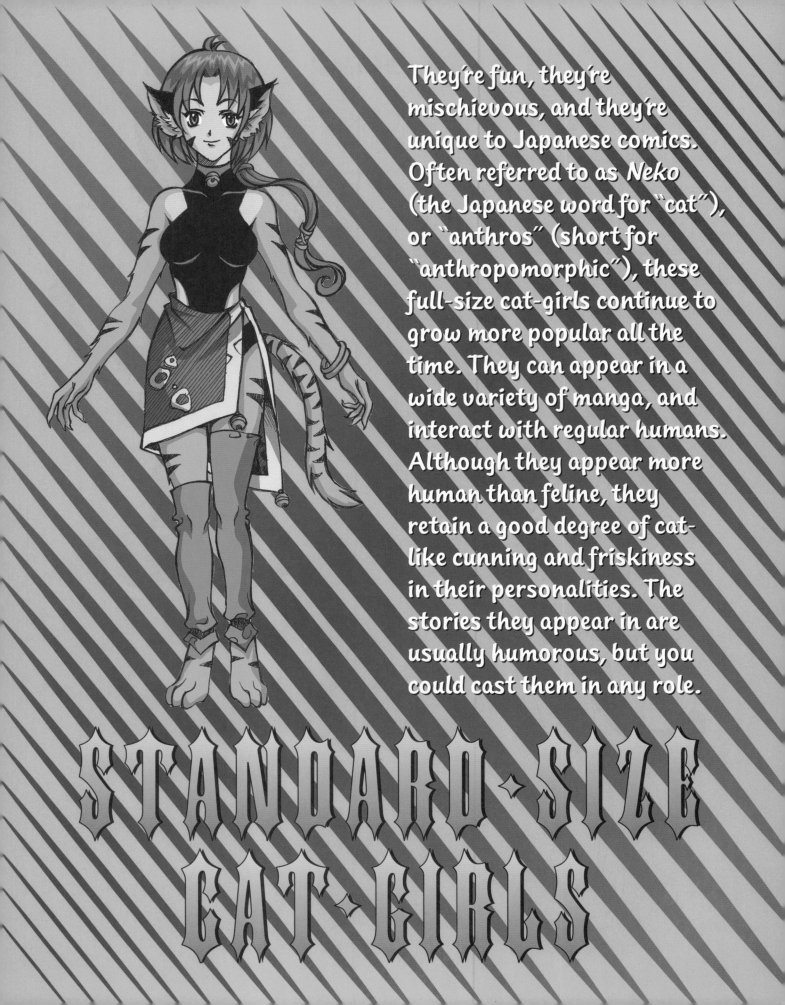

They're fun, they're mischievous, and they're unique to Japanese comics. Often referred to as *Neko* (the Japanese word for "cat"), or "anthros" (short for "anthropomorphic"), these full-size cat-girls continue to grow more popular all the time. They can appear in a wide variety of manga, and interact with regular humans. Although they appear more human than feline, they retain a good degree of cat-like cunning and friskiness in their personalities. The stories they appear in are usually humorous, but you could cast them in any role.

STANDARD-SIZE CAT-GIRLS

Standard-Size Cat-Girls: The Basics

Cat-girls are drawn with varying degrees of feline appearance. Sometimes they are only slightly reminiscent of cats. Other times, they are quite evolved. The more evolved they are, the more cat-like their personalities become. Cat-girls are attractive, playful characters who add a spark to the comic page. We'll cover all stages of cat-girl character design in this chapter.

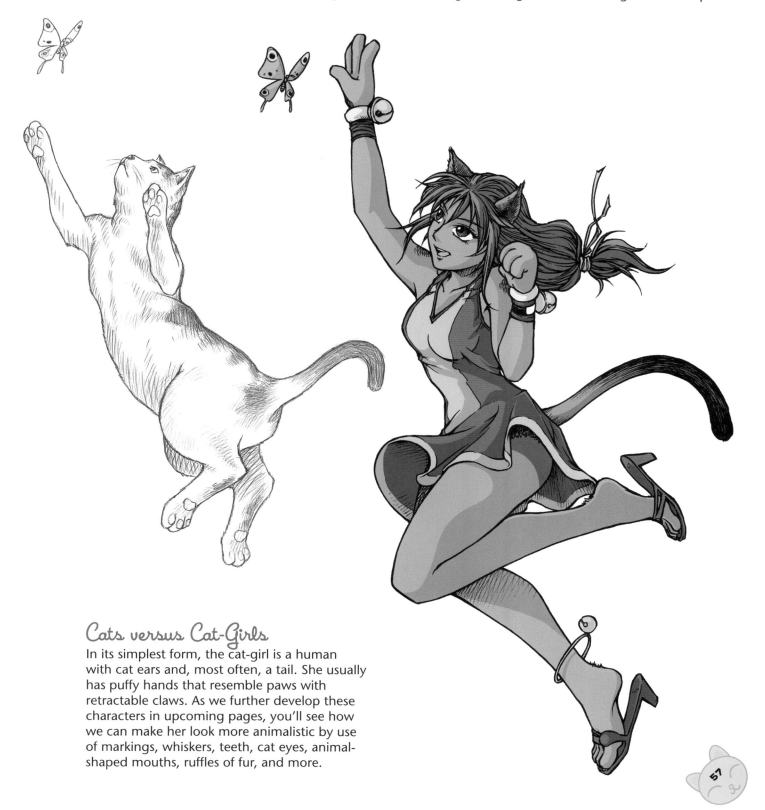

Cats versus Cat-Girls

In its simplest form, the cat-girl is a human with cat ears and, most often, a tail. She usually has puffy hands that resemble paws with retractable claws. As we further develop these characters in upcoming pages, you'll see how we can make her look more animalistic by use of markings, whiskers, teeth, cat eyes, animal-shaped mouths, ruffles of fur, and more.

A real cat stands on all fours. Although cat-girls sometimes assume that pose (for example, when hissing), they are bipedal characters. The legs of the cat-girl do not have the joint configuration of a real cat, but keep the regular, human kind of leg joints. This makes them easier to draw, because we're all familiar with how human knees bend (finally, we artists get a break!).

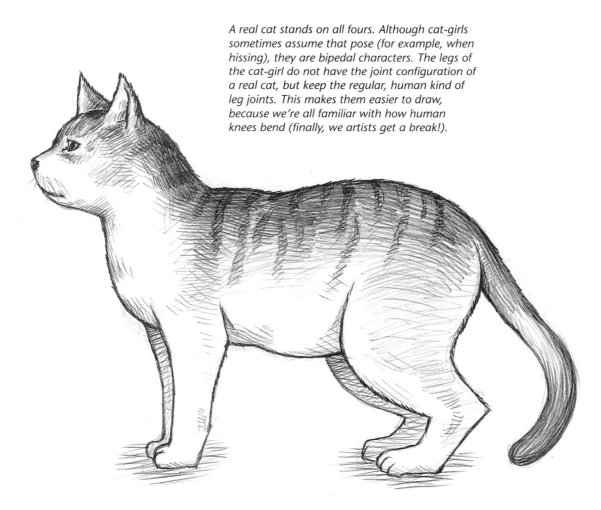

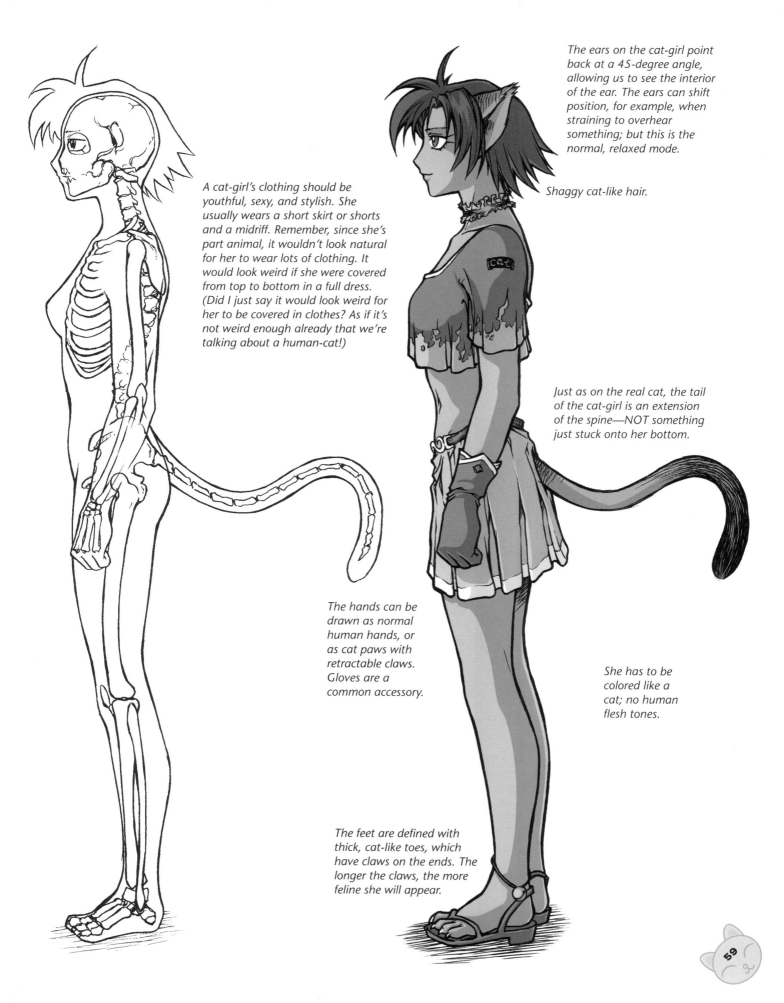

The ears on the cat-girl point back at a 45-degree angle, allowing us to see the interior of the ear. The ears can shift position, for example, when straining to overhear something; but this is the normal, relaxed mode.

Shaggy cat-like hair.

A cat-girl's clothing should be youthful, sexy, and stylish. She usually wears a short skirt or shorts and a midriff. Remember, since she's part animal, it wouldn't look natural for her to wear lots of clothing. It would look weird if she were covered from top to bottom in a full dress. (Did I just say it would look weird for her to be covered in clothes? As if it's not weird enough already that we're talking about a human-cat!)

Just as on the real cat, the tail of the cat-girl is an extension of the spine—NOT something just stuck onto her bottom.

The hands can be drawn as normal human hands, or as cat paws with retractable claws. Gloves are a common accessory.

She has to be colored like a cat; no human flesh tones.

The feet are defined with thick, cat-like toes, which have claws on the ends. The longer the claws, the more feline she will appear.

Drawing the Cat-Girl's Head Step-by-Step

Let's draw an attractive cat-girl's head with all of the details. First, draw a pretty manga face, then work in the cat-like features.

Front

Most full-sized cat-girls, like this one, are drawn as mature teenage characters, and even as twenty year olds. Keep the classic combination of big eyes, tiny nose, small mouth, and pointed chin that makes manga characters instantly recognizable.

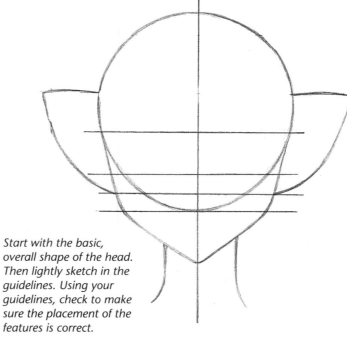

Start with the basic, overall shape of the head. Then lightly sketch in the guidelines. Using your guidelines, check to make sure the placement of the features is correct.

Bottom of ears placed at same line as bottom of nose.

Upper lip is at same level where jaw begins to angle inward toward chin.

Using human proportions as our guide, there should be one eye-length of space between the eyes. However, on manga characters, that space can be stretched even a little wider. The eyes don't float in the middle of the eyelids. Instead, the upper eyelids rest on top of the eyes, touching them.

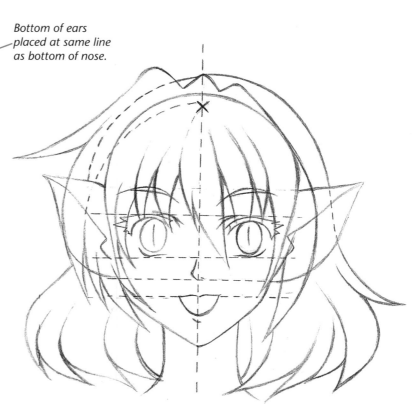

60

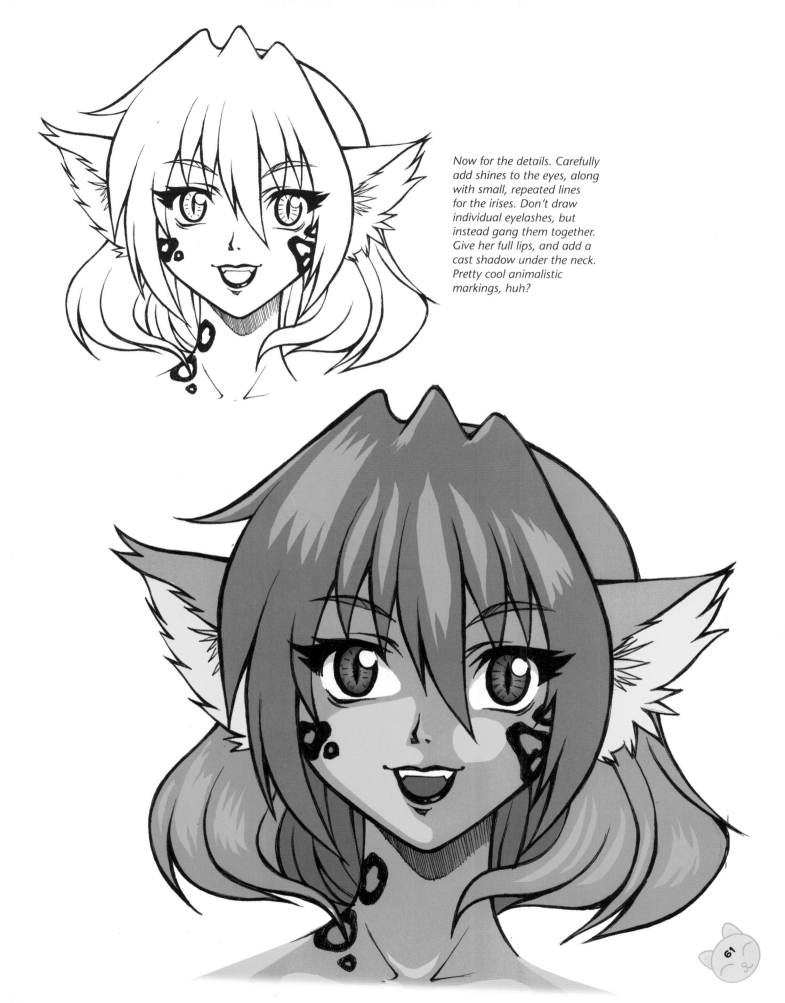

Now for the details. Carefully add shines to the eyes, along with small, repeated lines for the irises. Don't draw individual eyelashes, but instead gang them together. Give her full lips, and add a cast shadow under the neck. Pretty cool animalistic markings, huh?

3/4 View

In this view, three-quarters of the face appears on the right side (near side), with only a quarter on the left side (far side). The bridge of the nose acts as the dividing line. Because of perspective, the mouth and the eye on the near side of the face appear wider than on the far side of the face. Also, make sure you lose the far ear in the 3/4 view.

Far side = one quarter

Near side = three quarters

Notice that the neck begins far back on the head.

Cat ears stick out, and are drawn at a 45-degree angle.

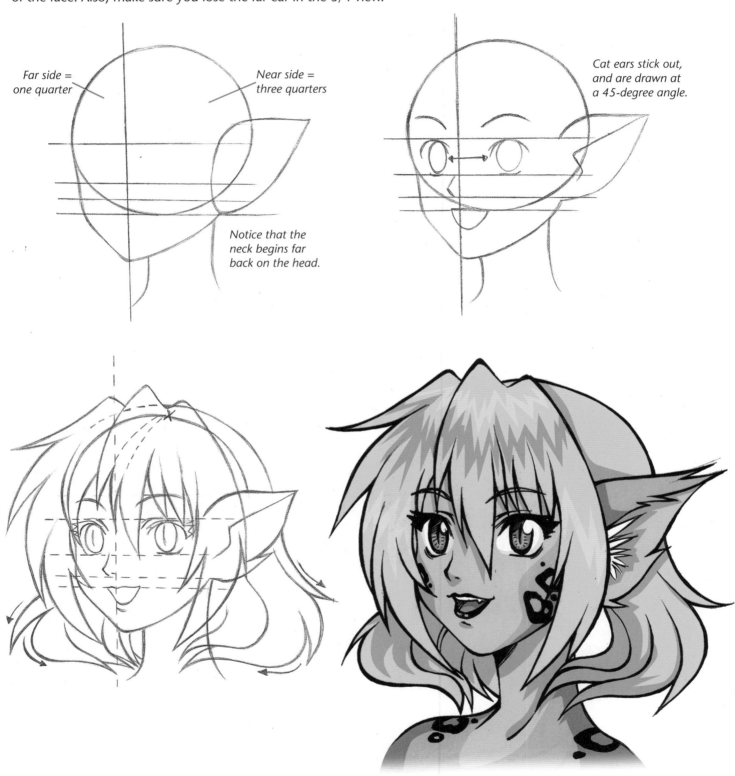

Side View

In the side view, the front of the face slants in at a diagonal, starting at the tip of the nose and ending at the bottom of the chin. This diagonal line is a very important feature in drawing manga characters! It's a hallmark that's carried over to all manga characters, including humans. Very few manga characters have chins that jut forward.

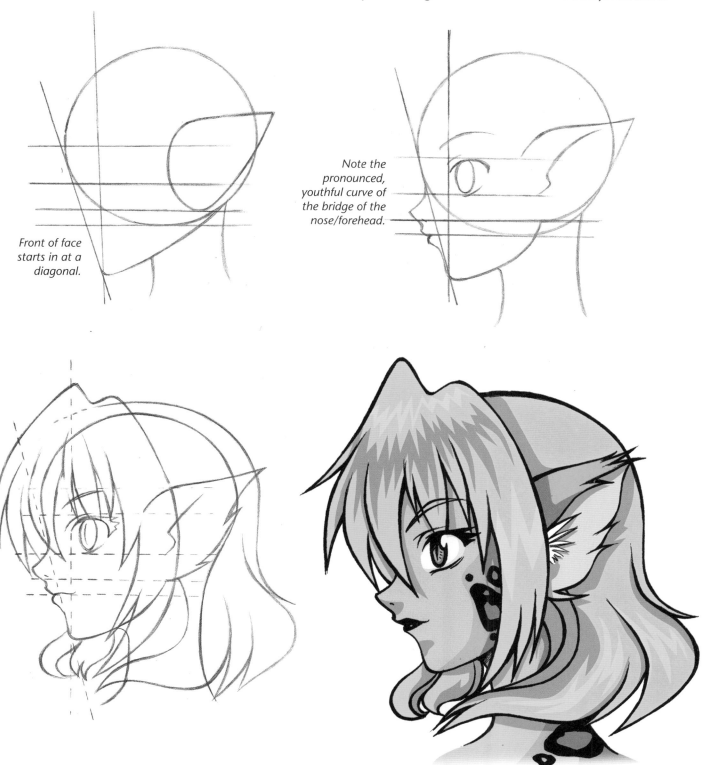

Front of face starts in at a diagonal.

Note the pronounced, youthful curve of the bridge of the nose/forehead.

Cat-Girl Head versus Human Head

By comparing the human girl to the cat-girl, we see that it's not one big change that creates the cat-girl look, but rather, an accumulation of small changes. The ears are the primary and most obviously distinguishing feature of the cat-girl. Like a real cat, the cat-girl eyes have a sleek black outline that accentuates their almond shape. The pupils are sharp. The cat-girl mouth has small, cat teeth. (Make sure the teeth are petite, or they may make your character look unattractive.) There's a hint of a black, cat-like nose at the tip.

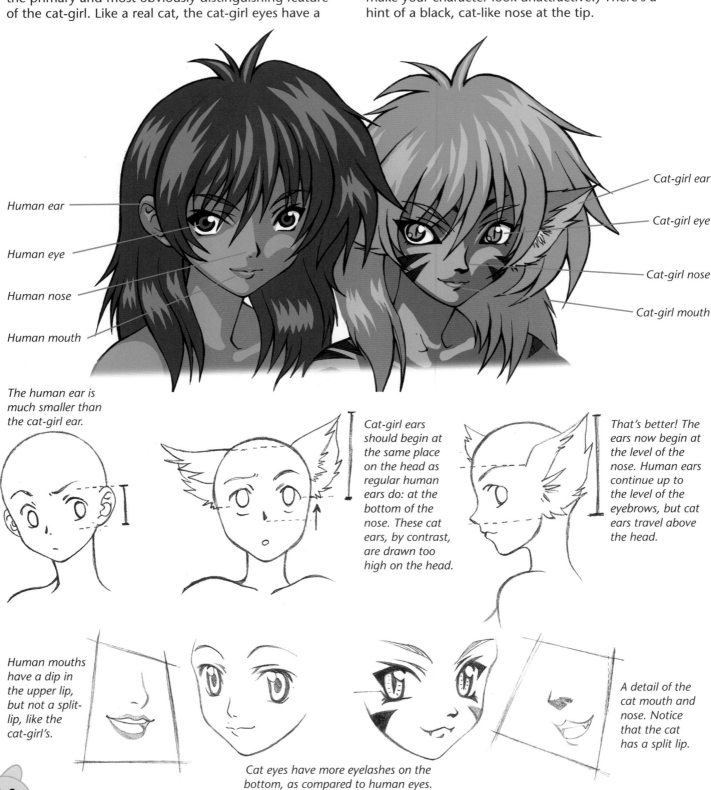

Human ear

Human eye

Human nose

Human mouth

Cat-girl ear

Cat-girl eye

Cat-girl nose

Cat-girl mouth

The human ear is much smaller than the cat-girl ear.

Cat-girl ears should begin at the same place on the head as regular human ears do: at the bottom of the nose. These cat ears, by contrast, are drawn too high on the head.

That's better! The ears now begin at the level of the nose. Human ears continue up to the level of the eyebrows, but cat ears travel above the head.

Human mouths have a dip in the upper lip, but not a split-lip, like the cat-girl's.

A detail of the cat mouth and nose. Notice that the cat has a split lip.

Cat eyes have more eyelashes on the bottom, as compared to human eyes.

Drawing Cat-Girl Bodies Step-by-Step

When you draw the female body, it's important to notice how wide the hips are. The thighbone connects to the hips at its widest point. As the thighbones travel down to the knees, they slant inward, at a diagonal; they do not go straight down. From the knees to the feet, the bones of the lower legs travel straight down in a vertical line. You can observe this by looking at the stick figure that has been drawn inside the outline of the body in the first step.

Collarbone

Front

Thighbone

Thighbone starts in at the knee.

Cat-girls always wear casual-chic clothes.

Side View

Here are a few more tips: Female characters, especially those standing erect with good posture, exhibit a deep curve in the small of their back. The locked leg, which bears most of the weight, will always have a slight backward bend to it. Notice, too, that the upper body has athletic shoulders. Strength and beauty go together in this type of character. Also notice how the neck tilts slightly forward in a natural stance.

Neck tilts forward.

Shoulders are muscular.

Curve in lower back.

Locked leg bends slightly backward at the knee.

Torso bends outward.

From Tame to Wild

So far, I've only introduced cat-girls in their most human form. Although they have displayed numerous cat-like idiosyncrasies and feline personalities, their appearance is by and large human. But cat-girls comprise a wide spectrum, and the characters run the gamut from tame to wild. Let's take a look at the three major levels of cat-girl character development as it relates to their human to animal evolution.

Basic Cat-Girl

At her most basic, the cat-girl has cat-ears and a tail on a pretty, human physique. She will often also wear arm-length gloves and leggings, covering up her cat-like furry patches and perhaps also hiding her paws and claws.

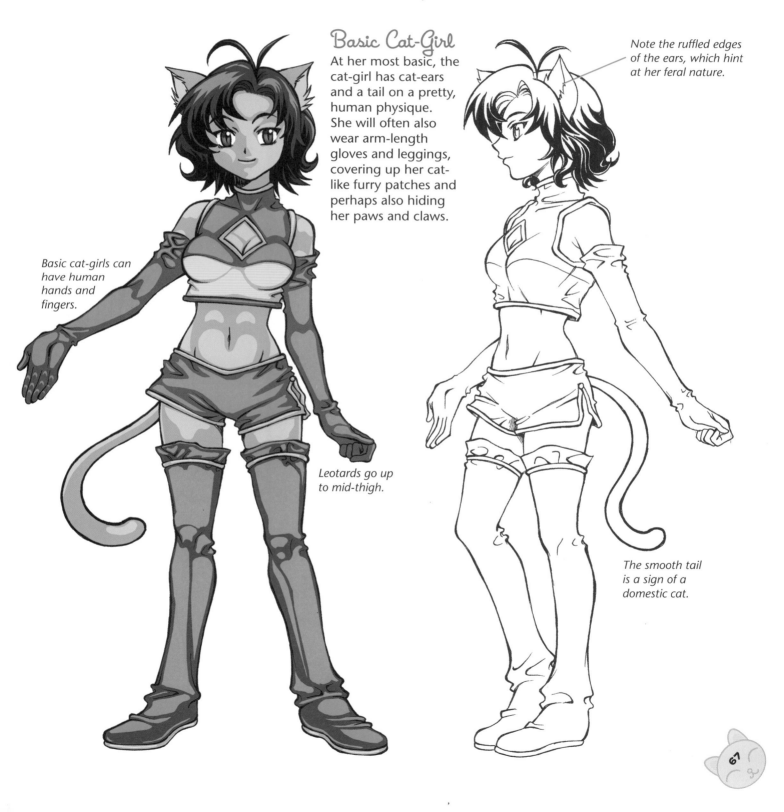

Note the ruffled edges of the ears, which hint at her feral nature.

Basic cat-girls can have human hands and fingers.

Leotards go up to mid-thigh.

The smooth tail is a sign of a domestic cat.

67

Intermediate Cat-Girl

This cat-girl has evolved much further than the basic cat-girl. She is much more in the realm of feline, although she retains a lot of her human characteristics. So what has changed? Instead of arm-length gloves and leggings, which appear to be part of her clothing, these gloves and leggings are made of fur, and are ruffled throughout. The feet have been turned into paws. And her hair is longer, giving her an untamed look. Still, like all cat-girls, she has a pretty appearance and charming personality.

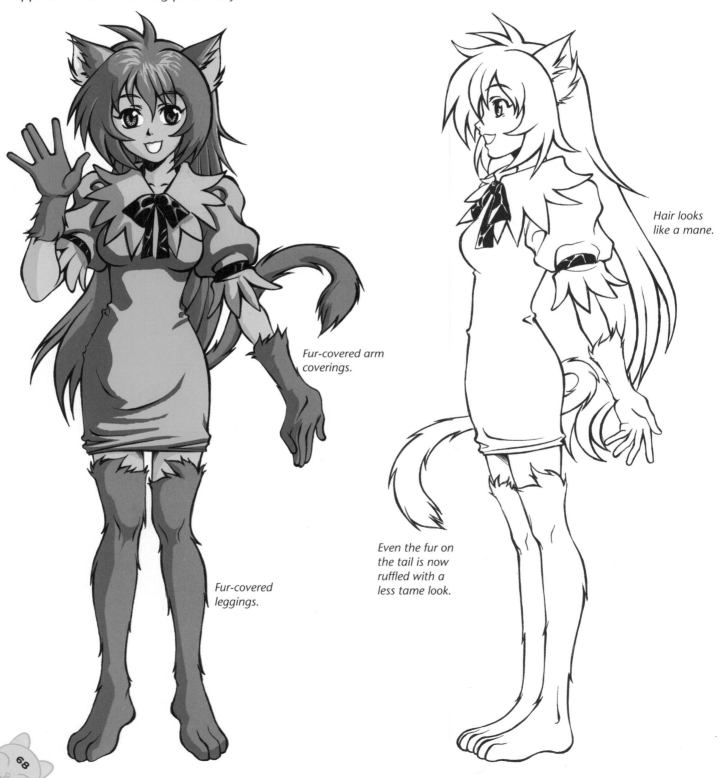

Fur-covered arm coverings.

Fur-covered leggings.

Hair looks like a mane.

Even the fur on the tail is now ruffled with a less tame look.

Fully Evolved Cat-Girl

Our third and last stage of cat-girl evolution shows a character which is more cat than human. Every part of the character has the features and markings of a cat. And, note the tiger stripes. As the cat-girl became more cat-like, she took on the characteristics of a big cat, not a little house kitten. Yes, at this stage, she can be a dangerous character! The arm-length gloves and leggings are gone, replaced with a coat of fur, from top to bottom.

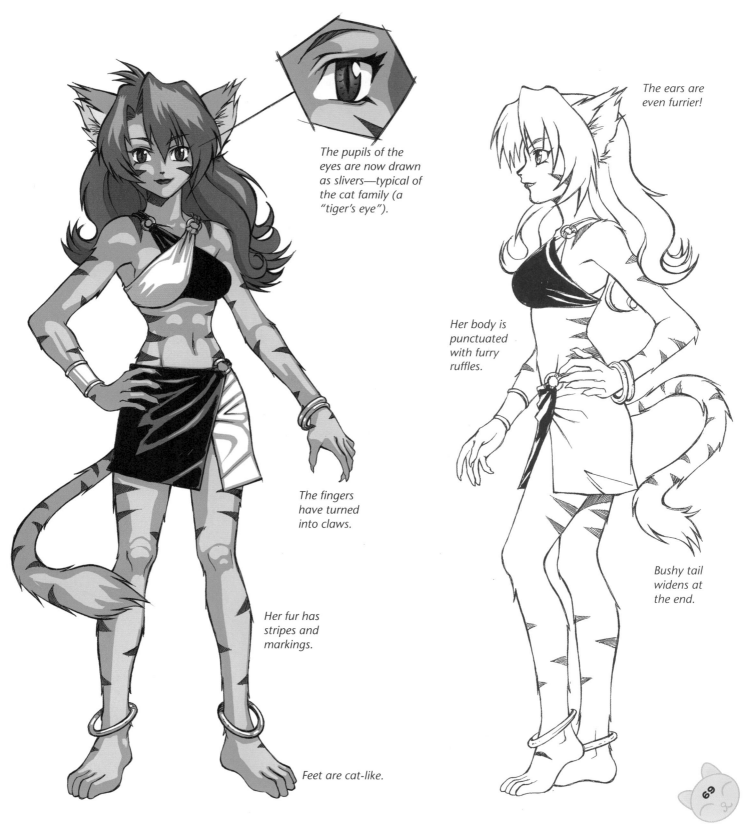

The pupils of the eyes are now drawn as slivers—typical of the cat family (a "tiger's eye").

The fingers have turned into claws.

Her fur has stripes and markings.

Feet are cat-like.

The ears are even furrier!

Her body is punctuated with furry ruffles.

Bushy tail widens at the end.

69

Cat-Girl Hand and Foot Markings

Furry hands and feet are easy to draw—just change three simple elements: fingernails to claws; smooth skin to ruffles of fur; and then add markings. But be careful: too many markings on the face will make your cat-girl look ugly, and you don't want that. To avoid this problem, only put markings around the perimeter of the face.

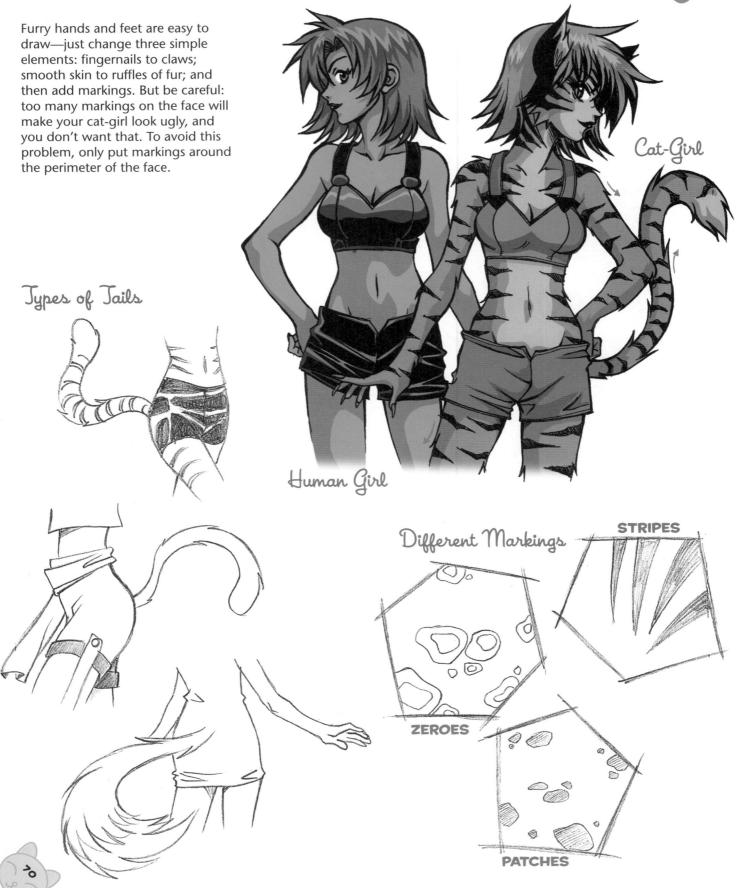

Cat-Girl

Types of Tails

Human Girl

Different Markings

STRIPES

ZEROES

PATCHES

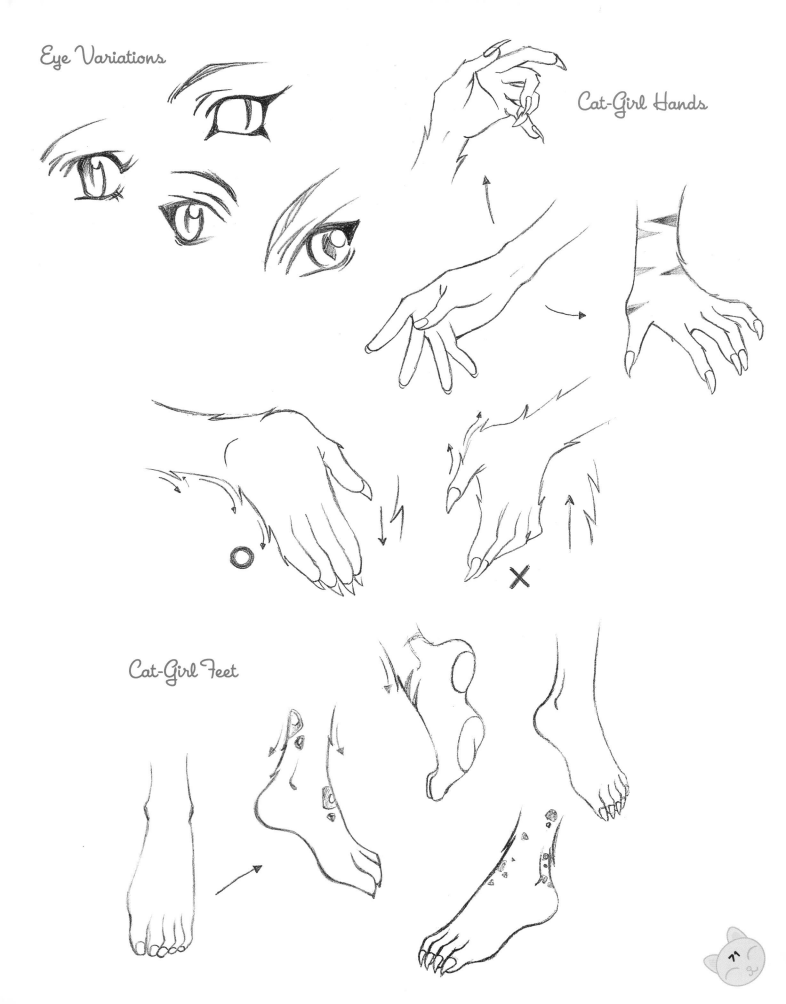

Eye Variations

Cat-Girl Hands

Cat-Girl Feet

71

Cat-Girl Personalities

For the most part, cat-girls interact with each other and with human characters just like any other girls. But, during extreme emotions a cat-girl's true, cat-like personality will show through. And even if there isn't an extreme emotion, you should still toss in a few cat-like reactions every once in a while—it makes for a more interesting character. Just be sure not to lay it on too thick; otherwise, it becomes played-out, rather than an interesting side note. After all, you don't want her showing up everywhere with a dead mouse hanging from her mouth. I had a girlfriend who used to do that as a gag. Boy, was that disgusting. (Had you going there for a minute, didn't I?)

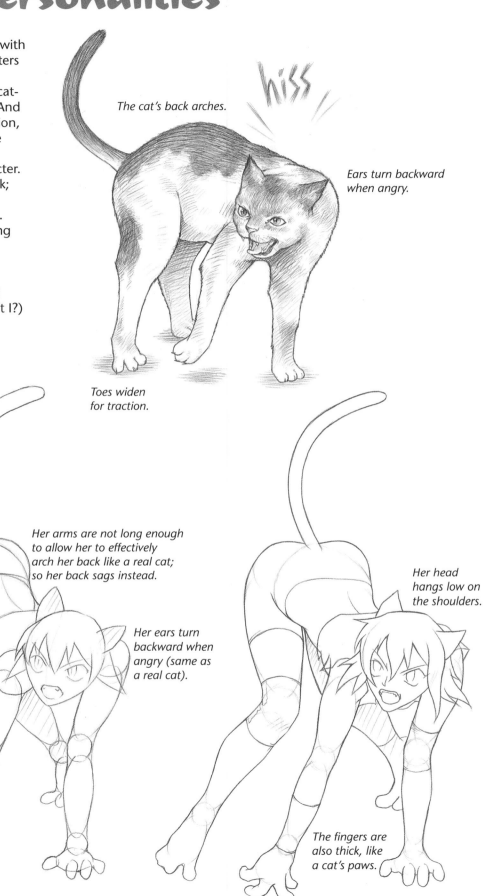

The cat's back arches.

hiss

Ears turn backward when angry.

Toes widen for traction.

The tail goes up—a sign of stress.

Her arms are not long enough to allow her to effectively arch her back like a real cat; so her back sags instead.

Her ears turn backward when angry (same as a real cat).

The toes are thick, like a cat's, and have claws instead of toenails.

Her toes widen for traction.

Her head hangs low on the shoulders.

The fingers are also thick, like a cat's paws.

Classic Hissing Posture

Ever hear of someone having a "hissy-fit"? It comes from cats who "hiss" before they bite. We all know it's not wise to mess with an angry cat.

A cat-girl's feline personality is best indicated by her posture. Cat-girls can assume four-legged postures when they mimic classic feline poses, like this classic cat "hiss."

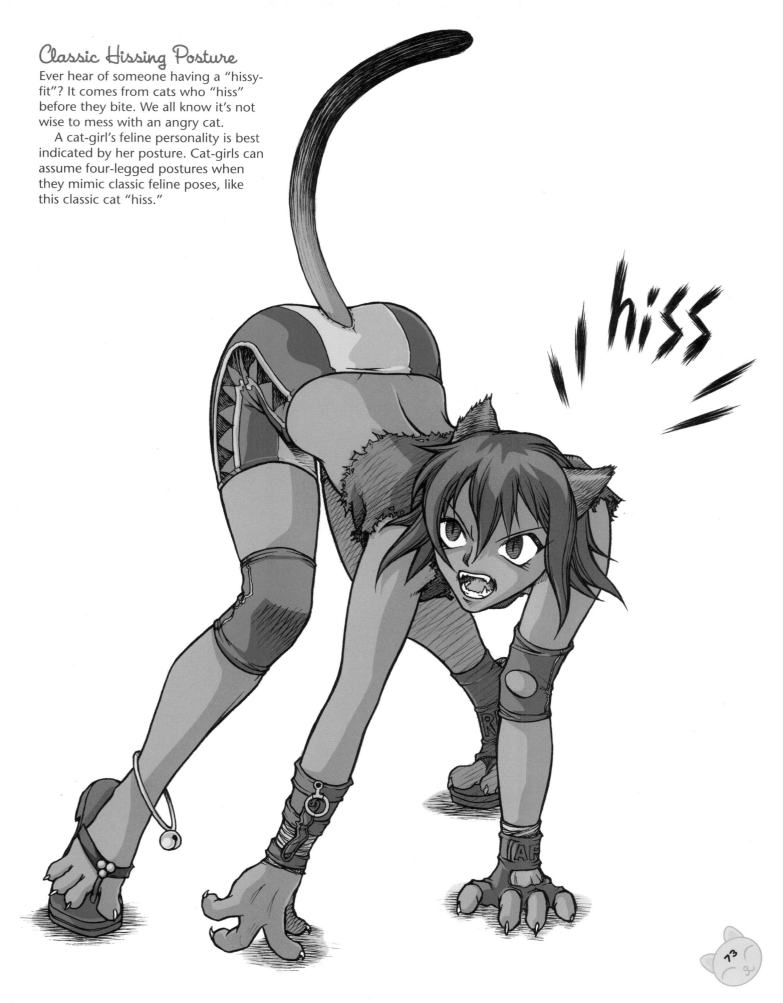

hiss

Cat-Girl Poses

In addition to having cat-like personalities, cat-girls often assume other classic cat poses. While the hissing cat posture is useful and effective, it's also good practice to toss in a few less serious cat-like poses. A sleepy or playful cat can add humor, and will remind the reader that, Hey, this character isn't just a pretty gal with strange ears, but rather a semi-human.

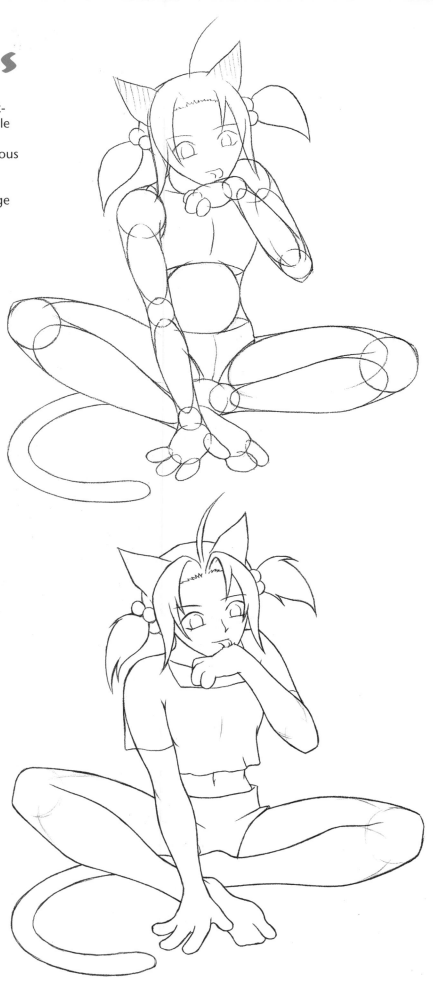

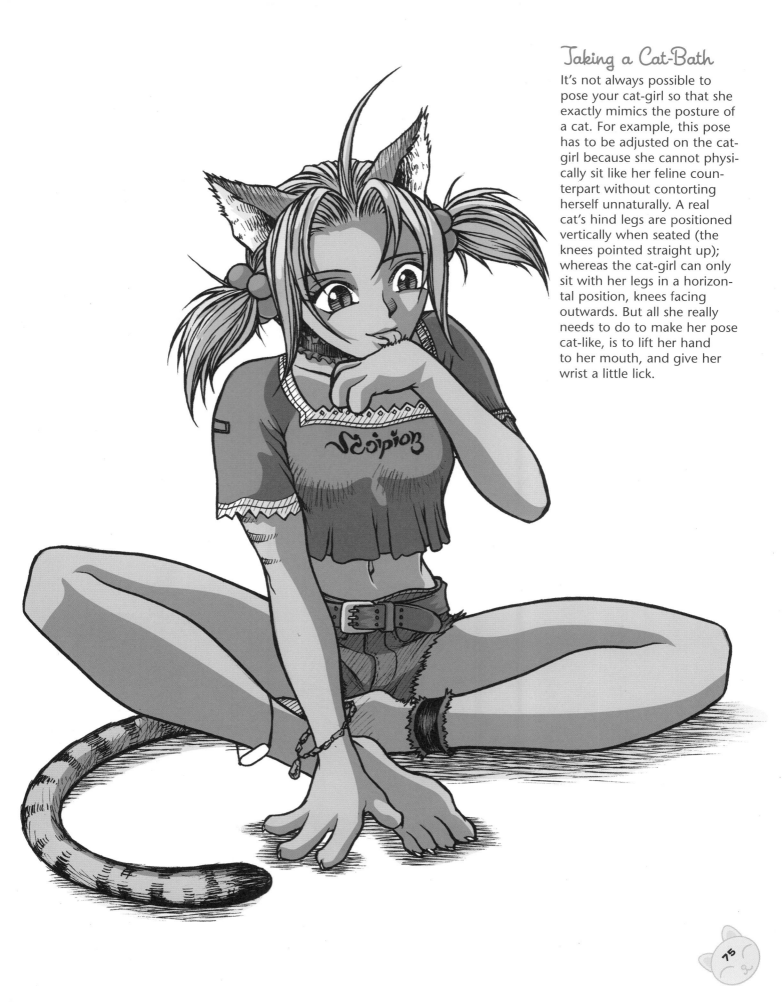

Taking a Cat-Bath

It's not always possible to pose your cat-girl so that she exactly mimics the posture of a cat. For example, this pose has to be adjusted on the cat-girl because she cannot physically sit like her feline counterpart without contorting herself unnaturally. A real cat's hind legs are positioned vertically when seated (the knees pointed straight up); whereas the cat-girl can only sit with her legs in a horizontal position, knees facing outwards. But all she really needs to do to make her pose cat-like, is to lift her hand to her mouth, and give her wrist a little lick.

S-t-r-e-t-c-h-e-s!!

All cats love to stretch, and our cat-girl is no exception. Cats all stretch the same way: Both arms out in front, with the bottom lifted up. The stretch is quite enjoyable to cats, and their expressions should reflect that.

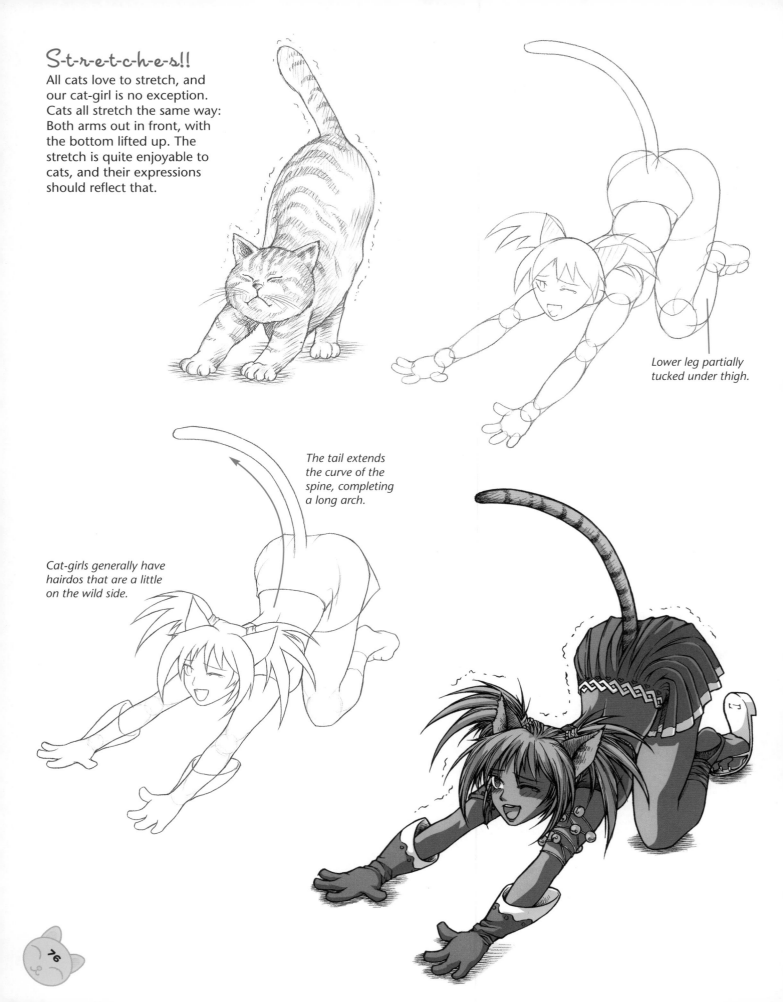

Lower leg partially tucked under thigh.

The tail extends the curve of the spine, completing a long arch.

Cat-girls generally have hairdos that are a little on the wild side.

Kitty Greeting

Here's a cat-girl in an affable mood. Similar, in a way, to the "hissing" pose, this friendly gesture has a few important differences. First, there is no tension in the body. The head is held high. And her shoulders are higher than her bottom, which is exactly the reverse of the hissing pose.

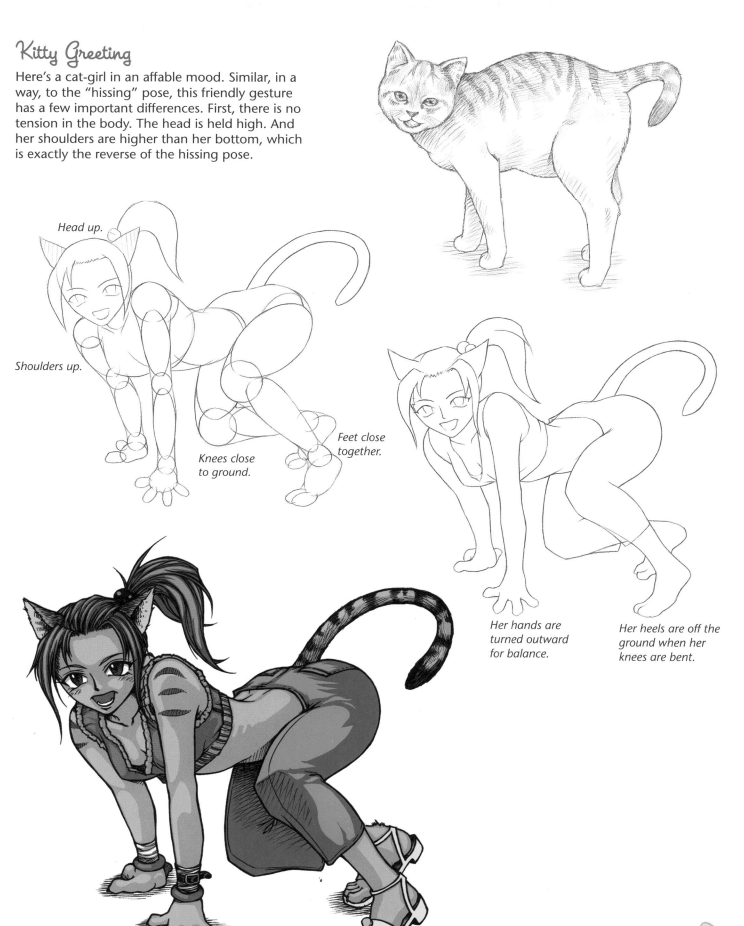

Head up.

Shoulders up.

Knees close to ground.

Feet close together.

Her hands are turned outward for balance.

Her heels are off the ground when her knees are bent.

77

Yarn Play

Cats love to smack around a ball of yarn. Cat-girls, too, enjoy the hypnotic effect of batting a ball back and forth between their paws, er, hands. Cats always hit balls from the side with an open paw. Therefore, to create a cat-like feeling you can show your cat-girl doing the same thing.

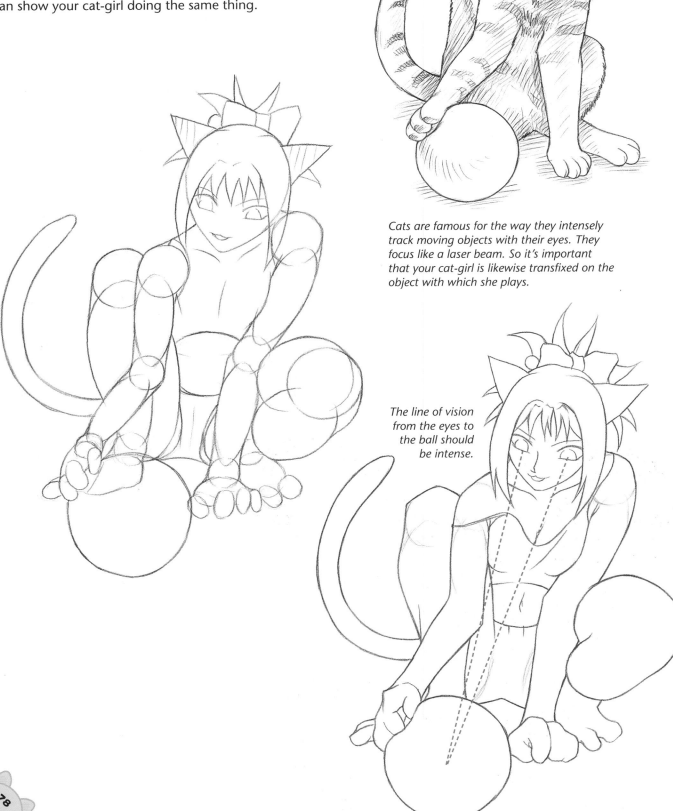

Cats are famous for the way they intensely track moving objects with their eyes. They focus like a laser beam. So it's important that your cat-girl is likewise transfixed on the object with which she plays.

The line of vision from the eyes to the ball should be intense.

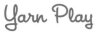

78

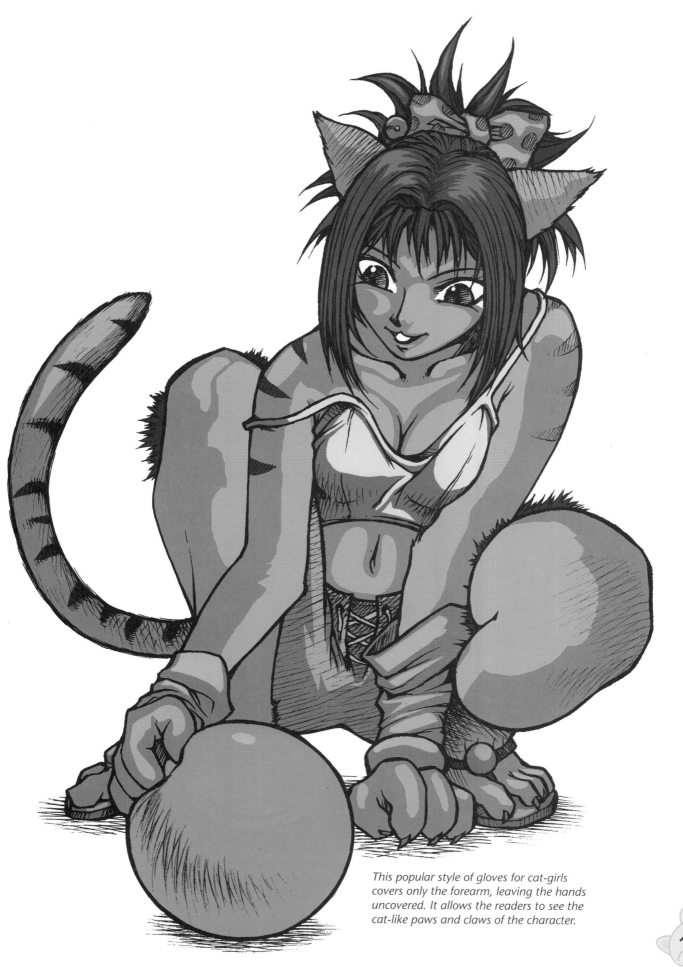

This popular style of gloves for cat-girls covers only the forearm, leaving the hands uncovered. It allows the readers to see the cat-like paws and claws of the character.

Cat-Girl Scenes

Now let's draw cat-girls in a few scenes that are typical of what you would find in manga featuring these characters. It's amazing how well they fit into human circumstances, given that they're hybrids. Because they're fun, friendly, and attractive characters—not the animal-human freaks of American comics—they look completely natural in human surroundings.

To make sure that you are positioning the characters correctly against the background, use this "spot checking" method that art students learn in life-drawing class: Notice where the lines of the background intersect the character. Then position your character accordingly. (Don't worry if you need to do some erasing. It's part of the process!) For example, the line of the windshield intersects with the peak of the cat-girl's calf muscle (**3**). You'll also note that her lower foot is bracketed between two horizontal lines of the car (**2**). Further, her upper knee rises off the roof of the car (**1**). Midway between her knee and her ankle bracelet, her right calf (her right, our left) intersects with the vertical line where the two car windows meet (**4**). This is a good way to visually check your drawings when there are background scenes.

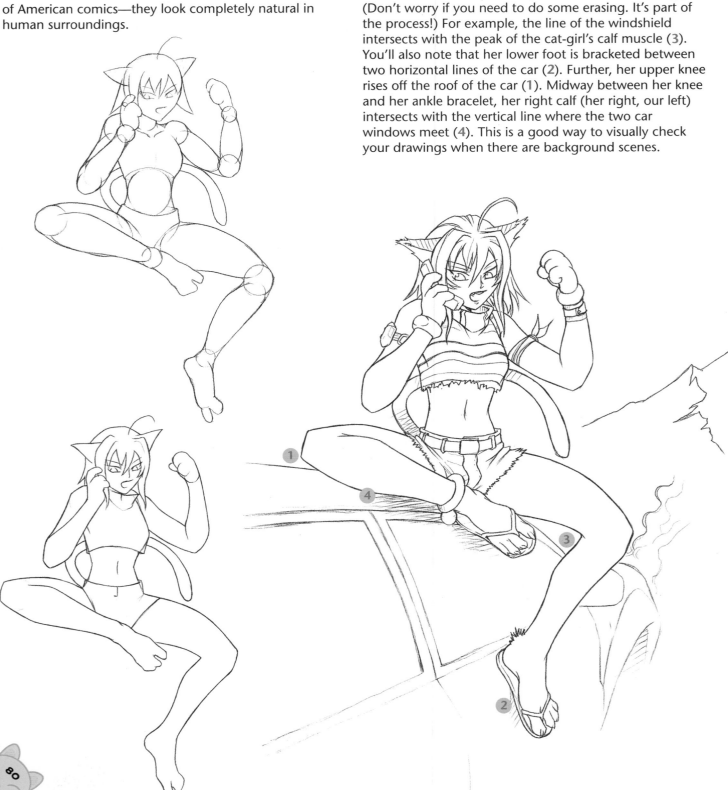

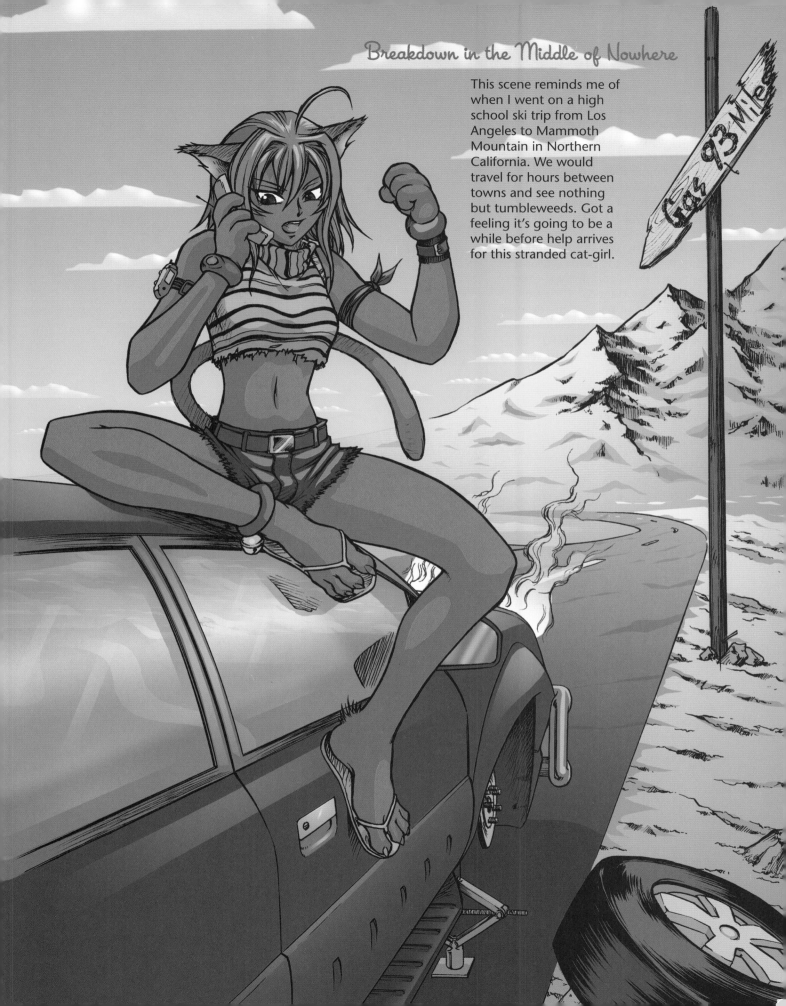

Breakdown in the Middle of Nowhere

This scene reminds me of when I went on a high school ski trip from Los Angeles to Mammoth Mountain in Northern California. We would travel for hours between towns and see nothing but tumbleweeds. Got a feeling it's going to be a while before help arrives for this stranded cat-girl.

Gas 93 Miles

Foreshortening

"Foreshortening" is a Latin term, which, loosely translated, means that anyone can be a manga artist if he or she practices diligently and reads books by Christopher Hart. Okay, maybe that was a very loose translation. The "formal" meaning, if you want to get technical about it (sheesh!), refers to objects that are drawn to look compressed. For example, when you look at a pencil from the side, it looks long. But if you turn it so that the point is facing you, the pencil looks compressed—hence, shorter, or "foreshortened." The same thing happens when parts of the human body are turned to face the reader (this occurs most often with the limbs). The best way to effectively foreshorten an object is to compress the size of the object being foreshortened. This means that the object not only gets shorter, but also a little bit wider.

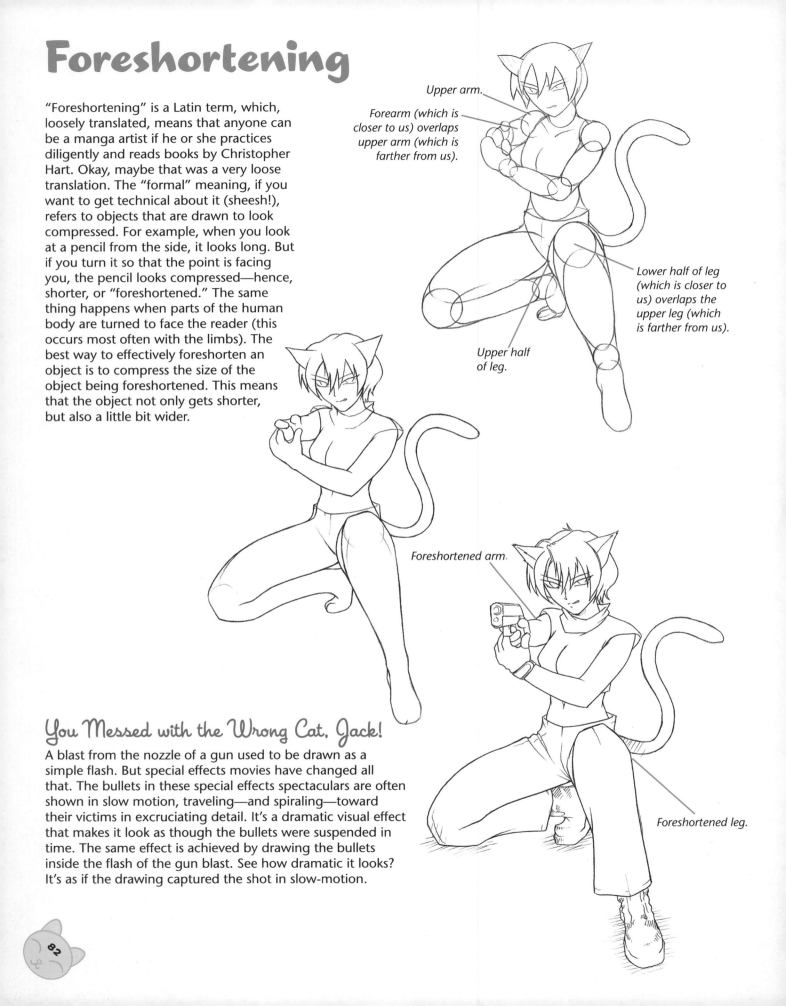

Upper arm.

Forearm (which is closer to us) overlaps upper arm (which is farther from us).

Lower half of leg (which is closer to us) overlaps the upper leg (which is farther from us).

Upper half of leg.

Foreshortened arm.

Foreshortened leg.

You Messed with the Wrong Cat, Jack!

A blast from the nozzle of a gun used to be drawn as a simple flash. But special effects movies have changed all that. The bullets in these special effects spectaculars are often shown in slow motion, traveling—and spiraling—toward their victims in excruciating detail. It's a dramatic visual effect that makes it look as though the bullets were suspended in time. The same effect is achieved by drawing the bullets inside the flash of the gun blast. See how dramatic it looks? It's as if the drawing captured the shot in slow-motion.

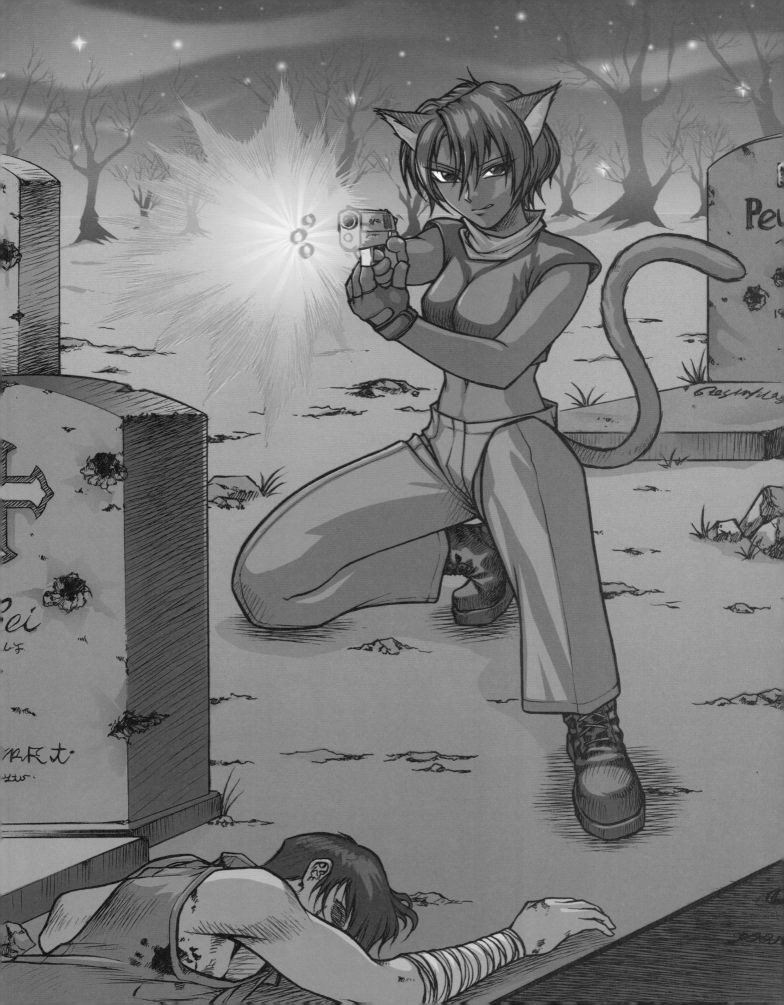

A World of Cat-Girls!

These two pages are devoted to the trendiest cat-girls—the ones that have made cat-girl characters so popular in manga. Each character is shown with a construction step that you can use to practice on when drawing. The poses are varied: there are sitting poses, standing poses, reclining poses, kneeling poses, as well as front and back poses.

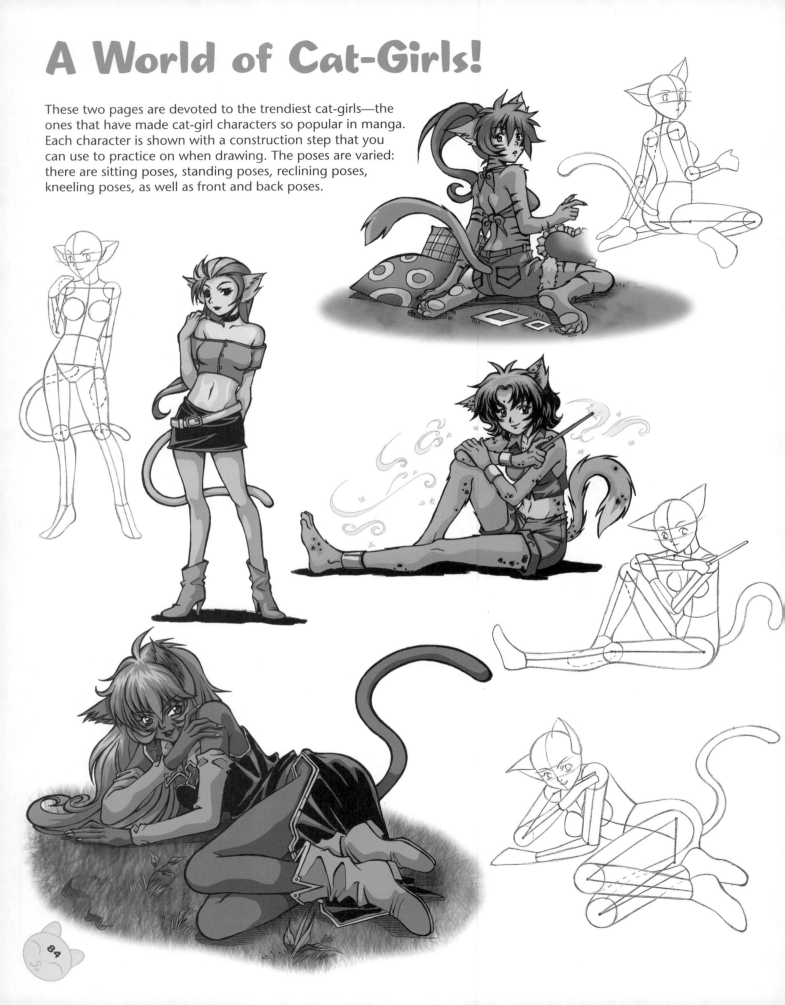

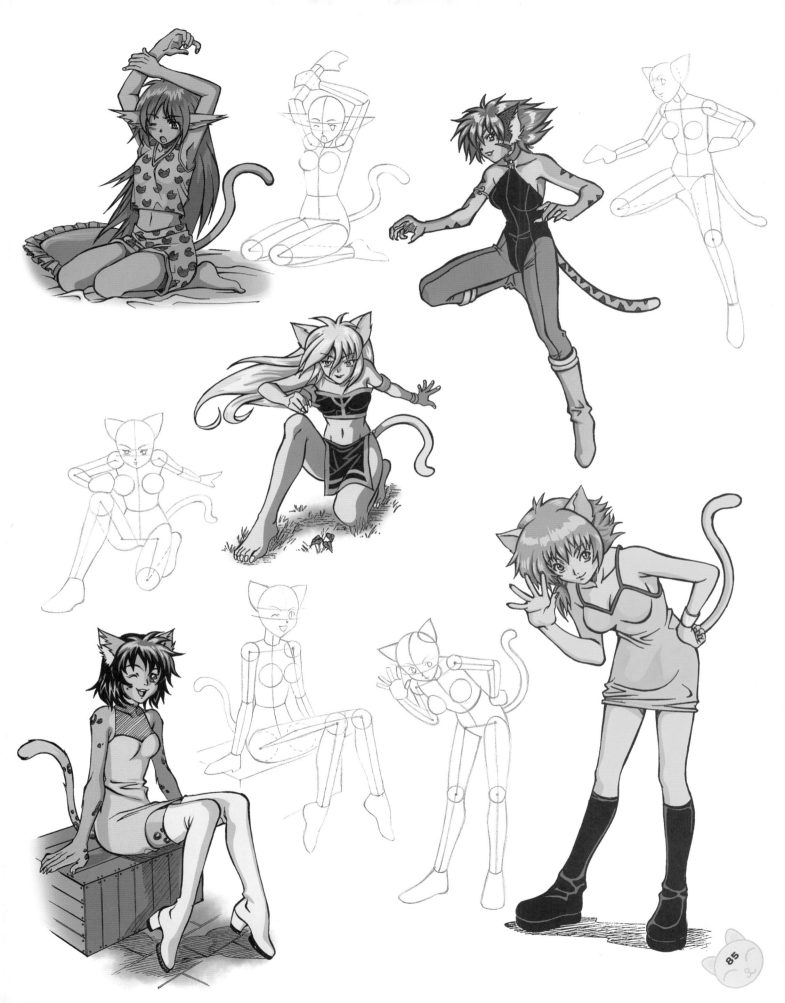

CHIBI MONSTERS AND MAGICAL CREATURES

The most popular chibis of all might just be the chibi-style monsters. These are cute little monsters—we're not talking Godzilla—which nonetheless have big powers that can be used for good, evil, or just to create mischief! These mini monsters can function as mascots, mentors, trusted friends, and guides. They can be based on real animals, simple shapes, or even inanimate objects, and they often have human pals or owners.

Standard Monsters versus Chibi Monsters

Now let's look at some regulation-size manga monsters (well, there's not actually an official "regulation size" for monsters, at least not until the manga monsters unionize). Standard manga monsters are ferocious creatures. They have sharp horns or spikes, massive claws, and look as though they can do a lot of damage. By comparison, chibi monsters look like stuffed carnival prizes that some mad scientist has altered to make scarier—yet not quite so scary that people will stop squeezing them.

Standard Manga Monster

This standard-size manga monster is five-heads tall, showing off its sinewy form. The eyes are small and intense, not big and cute like the chibi version. The tail is drawn with a lot of detail to make it look like a serious weapon. And look at those killer claws!

Chibi Monster

The chibi monster is two- to three-heads tall, which gives it chubby proportions. The body is round, not muscular. The nose and claws have been reduced in size, to lessen its ferocity, but the eyes and ears remain big (which makes him look friendlier). The outline of his fur is smooth, and less ruffled than the standard monster. The tail has also been simplified so that it looks more decorative than dangerous.

87

Creating Chibi Monsters from Basic Shapes

Let's start with the basics and then work our way up to more challenging monster characters with magical powers. The first step in drawing a chibi monster is to begin with simple shapes.

Triangles

A triangle can serve as the foundation for a chibi monster. First, section off the corners of the triangle. Next, decide where to place the eyes. Where you place the eyes determines, to a large extent, the look of the character, and whether it will be cute, silly, or strange. Add additional triangles to the outline of the figure to create the arms. Now soften the outline of the figure so that it doesn't look as if it were drawn with a ruler. Add stripes, markings, a mouth, and embellish the eyes.

Eyes up high and together = silly.

Eyes in the middle = cute.

Eyes down low and wide apart = strange looking.

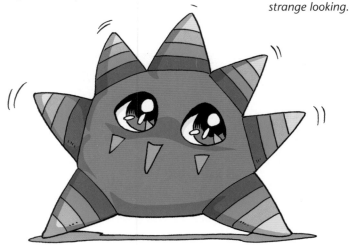

Eye Placement

The placement of the eyes helps create the unique look of the character. The wider apart they are, the cuter the character. The closer together they are, the goofier the character.

EYE STYLES

Dots

Lines

		Far Apart	Close Together
BASIC POSITION			
SLIGHTLY HIGH			
SLIGHTLY LOW			

Circles

The circle is a friendly shape, but too plain to work all by itself as the basis for a chibi monster. However, if you add circles onto circles, then you can come up with something fun. Let's give it a try.

Start with a circle. You can draw it freehand—it doesn't matter if it's not perfectly round.

To create the eyes, draw two more circles on the top of the head. To create the body, draw one more circle underneath the first circle.

Now add wings, feet, and a silly tail. Cut out a pie-wedge for the mouth. Two slits near the mouth become the nostrils.

Put tiny pupils in the huge eyes, and add the details.

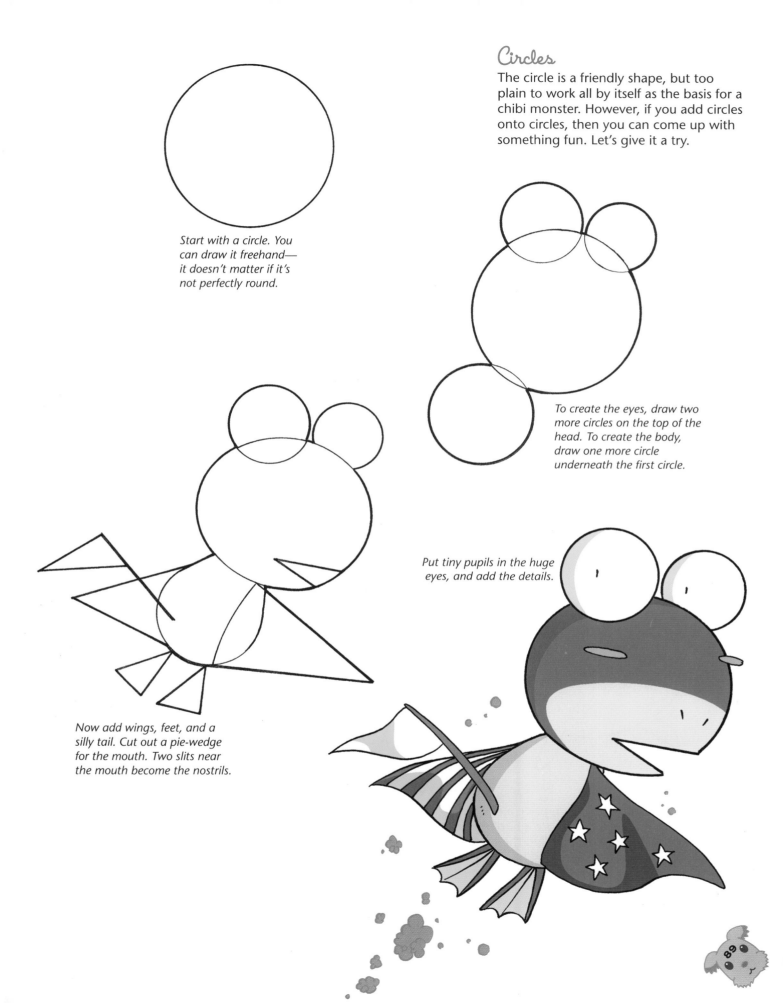

Creating Chibi Monsters from Inanimate Objects

Common household objects that are turned into chibis are always humorous-looking, which is why readers love them. Anything can serve as inspiration for a chibi monster. Take a teapot, for example. Look at it from all angles. Tilt it, rotate it, until something occurs to you. The little spout looks a bit like a bird's beak, doesn't it? That's all you need to begin the metamorphosis.

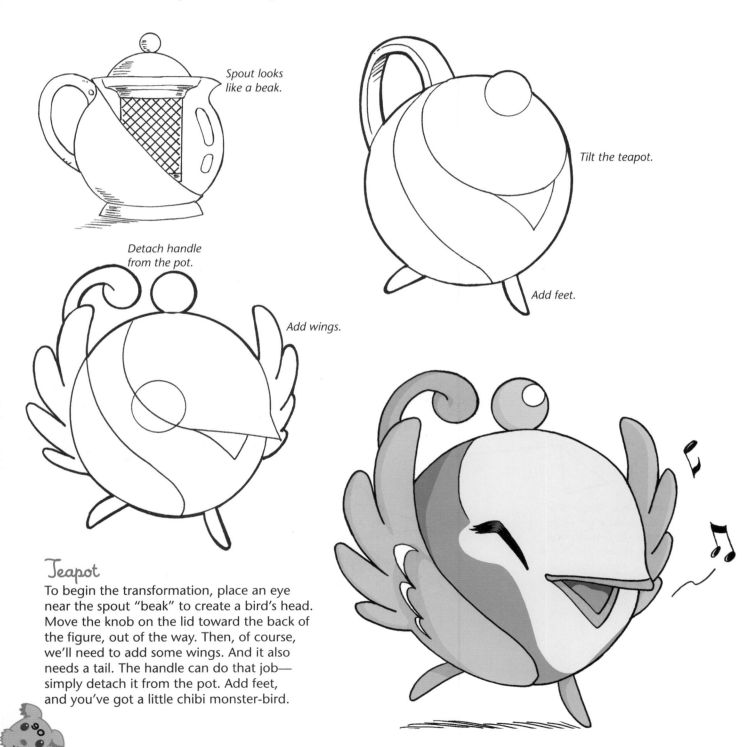

Spout looks like a beak.

Tilt the teapot.

Add feet.

Detach handle from the pot.

Add wings.

Teapot
To begin the transformation, place an eye near the spout "beak" to create a bird's head. Move the knob on the lid toward the back of the figure, out of the way. Then, of course, we'll need to add some wings. And it also needs a tail. The handle can do that job—simply detach it from the pot. Add feet, and you've got a little chibi monster-bird.

Turn a Fan into a Chibi

There is an art to turning things into chibis. It starts by analyzing an object visually. A fan is hypnotic, especially when the blades rotate at high speeds. The moving blades create a mesmerizing blur. When turning a fan into a chibi, make sure to maintain that special aspect of the design.

The blades are arranged around a hub, which is a circle. As the center of attention, this hub—or circle—would be a natural place to put the chibi head.

It follows that the stand would become the monster body. Next, the chibi needs arms, which naturally have to attach to the body. Finish up with two little feet on the bottom, and you've just made another chibi monster. Now you can see that the art of character design is not a matter of pure inspiration: there's a lot of strategic thinking involved.

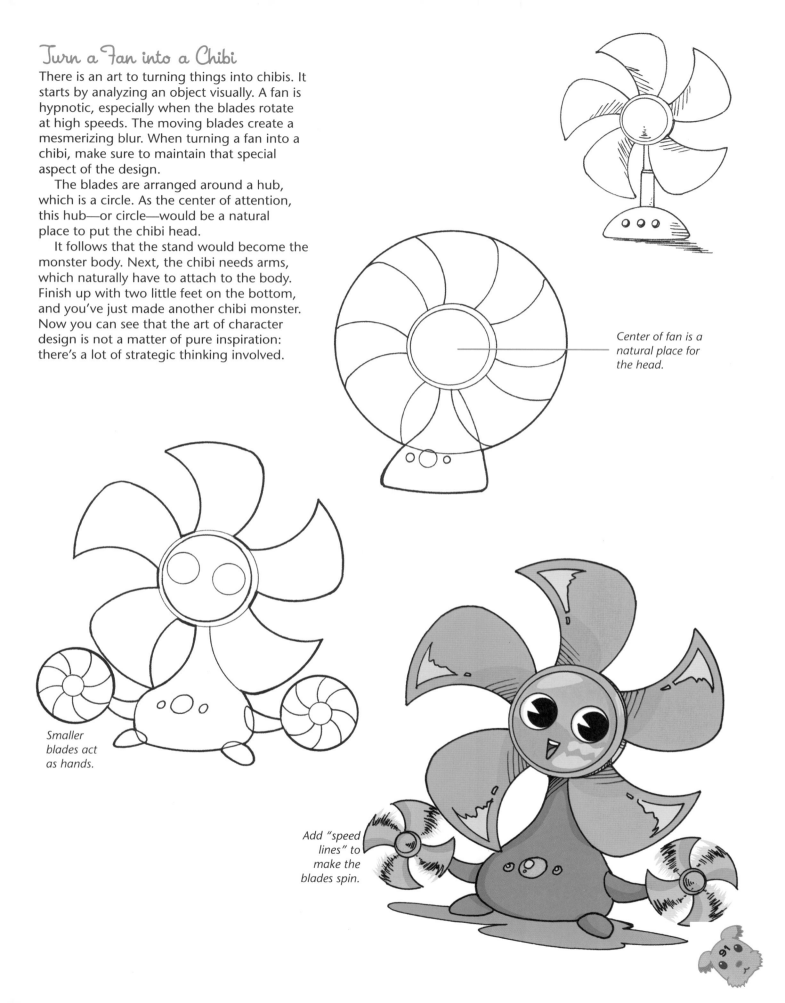

Center of fan is a natural place for the head.

Smaller blades act as hands.

Add "speed lines" to make the blades spin.

Creating Chibi Monsters from Animals

Animals are the most popular source material for chibi monsters. But it's not always a literal animal that forms the basis of the chibi monster. Often, it is a "cartoonized" version of an animal that becomes a chibi. Take this mouse, for example. A real mouse is not that cute. If real mice were cute and adorable, why would women scream when they saw one? So instead, we begin with a cartoon version of a mouse: big ears, chubby face, and a small nose. Now we're sure to come up with something adorable.

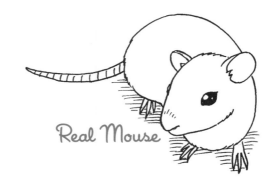

Real Mouse

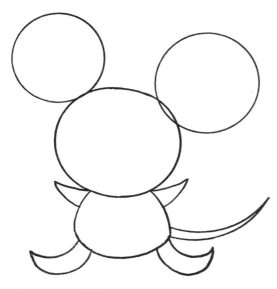

Cartoon Mouse

The cartoon mouse, like other chibi shapes, is simplified: The head and ears are basically three circles. Begin your chibi monster mouse with the same basic shapes as the cartoon mouse and then add more details to further develop the character. As you continue, the character's appearance will begin to diverge from the cartoon mouse and present itself as a unique chibi monster. For example, the ears take on a different shape.

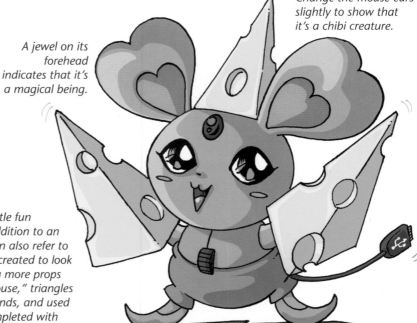

Change the mouse ears slightly to show that it's a chibi creature.

A jewel on its forehead indicates that it's a magical being.

Now we're going to have a little fun with the word "mouse." In addition to an animal, the word "mouse" can also refer to a computer piece. So a tail is created to look like a cable with a plug. Using more props associated with the word "mouse," triangles of cheese are added to the hands, and used as a hat. The character is completed with a little Dutch outfit with pointy shoes.

Pterodactyl Chibi Monster

You wouldn't normally think of pterodactyls as cute. They were prehistoric birds—predators—with huge wings made of skin. But the second law of cartooning states that "Any animal can be cute, provided that it's drawn as a baby." (I forget the first law.) So we change the pterodactyl by giving it baby proportions: big head, giant eyes, a small mouth, and a chubby, little body. But baby dinosaurs are not chibi monsters. So we have to alter this baby bird to make it different. Out come the tiny, jagged horns. Gone is the beak. And to top it off, he (or is it a she?) has flower patterns on its hide, and blows smoke from its mouth. I bet your average pterodactyl can't do *that*.

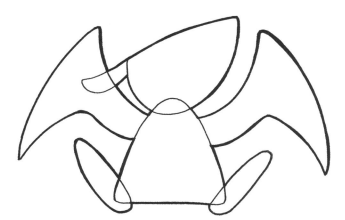

Chibis get chunky bodies!

Enlarge the eye to make it cuter.

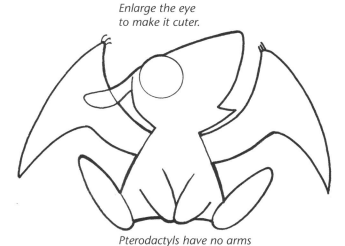

Pterodactyls have no arms (they are outgrowths of the wings), but chubby arms are cute, so add them anyway!

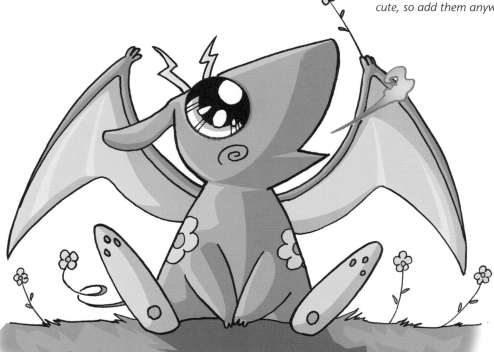

Fantasy-Animal Chibis

As you have seen on the previous pages, cartoon animals can be turned into unique chibis. Whereas regular manga animals are drawn somewhat realistically, chibi animals are fanciful, and can be altered in whimsical ways to make them part of manga's fantasy world. Chibi fantasy-animals often have special talents and powers, which you can build into the character design. If you want your chibi animal to be more attention-getting, begin with an unusual animal. Choose an animal that people don't see every day; in other words, no pets or farm critters.

Buffalo Chibi

A buffalo is a shag carpet with hoofs. Therefore, creating a chilly buffalo is a funny idea.

Panda Chibi

If he were any sweeter, I think I'd need a dentist.

 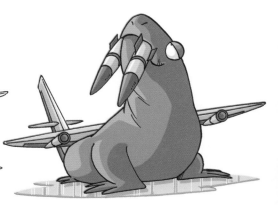

Walrus Chibi—Special Power: Missile Launcher

Flossing must be done very, very carefully.

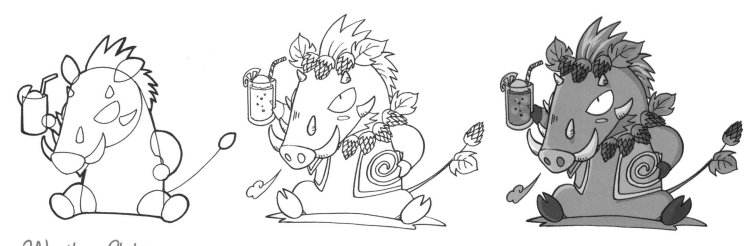

Warthog Chibi

A glass of soda pop, a loud outfit, and he looks like an ill-mannered tourist with tusks!

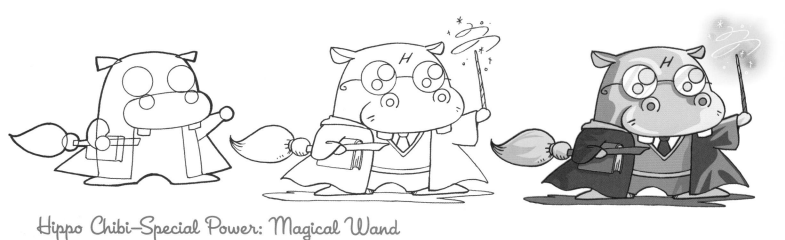

Hippo Chibi—Special Power: Magical Wand

Perhaps this one is a professor of magic. He's got all the appropriate props: professorial glasses, a wand, a book of magic, and a broomstick. The tie, vest, and long coat give him the look of academia.

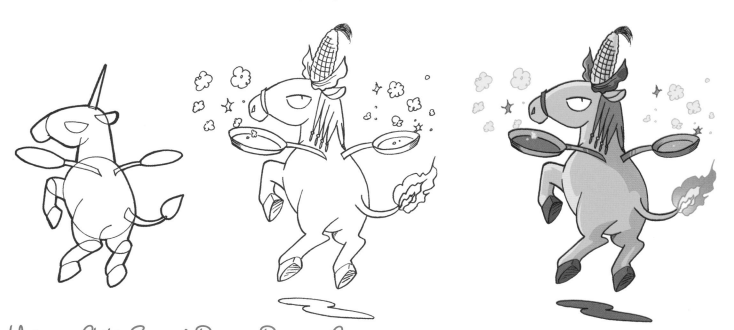

Unicorn Chibi—Special Power: Popping Corn

Uni-"corn." Get it, "corn"? You know, he's popping his own corn, and, er … ah well … never mind.

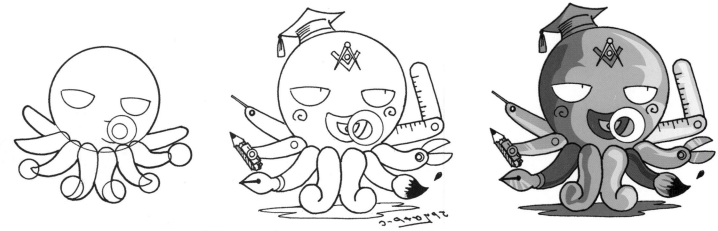

Octopus Chibi–Special Talent: Genius

An octopus is reported to be one of the smartest creatures of the sea—as smart as a dog. So we've taken that idea a step further. This overachieving little student is busy learning all about algebra, geometry, calculus, as well as how to suck the vital organs out of smaller fish.

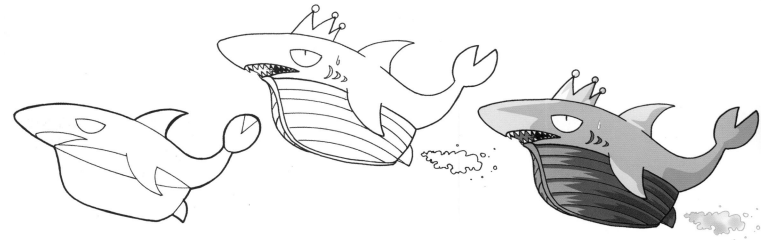

Shark Chibi–Special Powers: Swimming on Top of the Water

I bet you can guess what happened to the boat's former owner.

Fantasy-Clam Chibi–Special Powers: Martial Arts Master

A ninja clam? Yes, my friend, and it's the only crustacean that is feared by the U.S. military. This type of creature poses the most difficulty for beginning cartoonists who often believe that they must create an anthropomorphic form strictly based on an animal. But when you find yourself stuck with a simple shape that lends itself to so few permutations, it's wise to combine it with a pre-existing human form, marrying the two ideas instead of trying to somehow mold a quasi-hominid out of a clam shell.

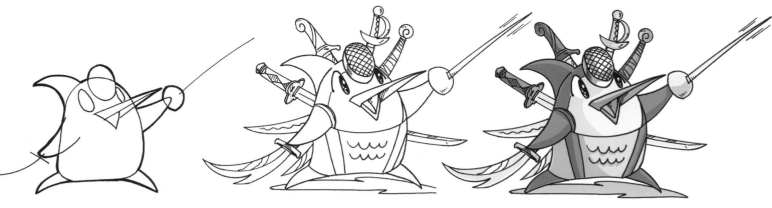

Emperor Penguin Chibi

Look at all those swords. He looks like a Swiss Army Knife made out of penguin. The beak has been elongated so that it doesn't look like an exact duplicate of a real penguin, which has a small beak. Because, as everyone knows, there weren't really any penguin musketeers in Merry Olde England. Back then, penguins were mainly into archery.

Fantasy-Stingray Chibi

This time, we've combined two different animals, a stingray and a rat, to produce the "stingrat," or a "ratway."

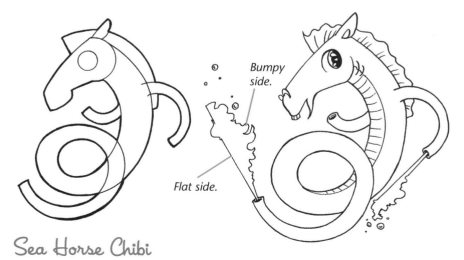

Bumpy side.

Flat side.

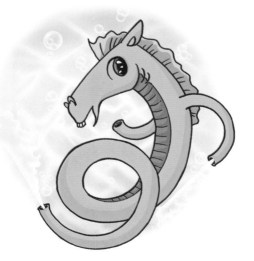

Sea Horse Chibi

Get it? Sea-"horse"? The head is actually a…oh, never mind…. A cool way to draw smoke is to leave one side flat, and the other side bumpy. This works with clouds, too. Clouds can be flat on the bottom and bumpy on top, but never the other way around.

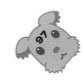

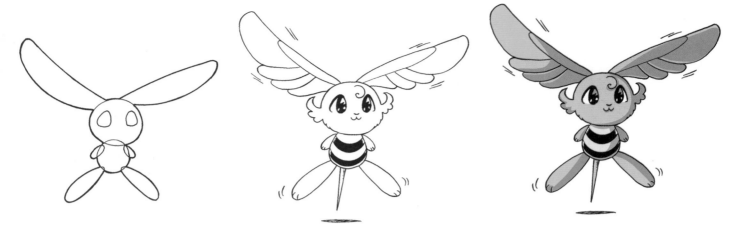

Fantasy-Rabbit Chibi—Special Power: Stinger

I've got one of these at home. They make great pets. But housetraining is tough. Just make sure they don't fly over any carpeting. This is a combo of a rabbit (ears, feet, mouth) and a bee (striped body and stinger). Long feet are as much a trademark of rabbits as long ears. Note the split upper lip, which is typical of small woodland mammals like rabbits and chipmunks.

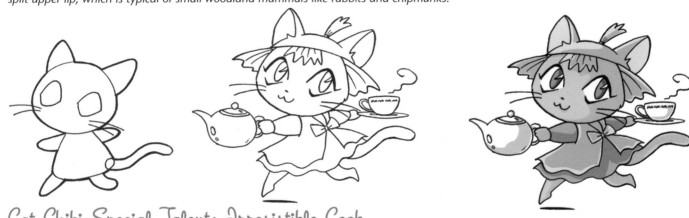

Cat Chibi—Special Talent: Irresistible Cook

Giving your chibi fantasy-animals special talents is a good way to give them more personality. There's no need to tip this cat. Just leave a fish head on the table next to the bill and she'll purr like a kitten.

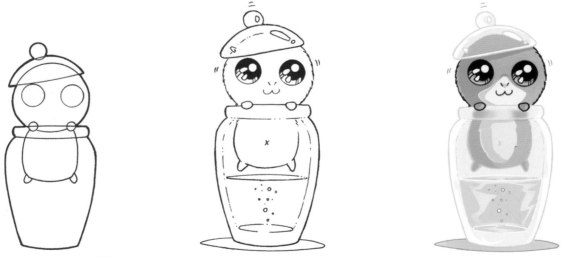

Gerbil Chibi—Special Talent: Getting Into Everything!

Gerbils are often a child's first pet. They are cute little critters, but have a fatal attraction to trouble. When chibi animals have very tiny arms and legs, you should not draw hands, finger, feet, or toes. It would look too busy. Just round them off.

Fantasy-Turtle Chibi-Special Talent: Built-In Cell Phone

By melding technology with an animal character, you come up with a turtle who can call out for pizza, which means no more having to stand behind a long line of reptiles just to get a calzone. Two antennae make a character look like an insect, which is often unattractive (the exception being fairies). But a single antennae gives a character a mysterious look. The fun in this pose is that he can't quite reach his own keypad!

Crested Fantasy-Penguin Chibi-Special Talent: Police Investigator

I know it's weird to see a penguin dressed as a cop, but not when you consider that his dad was also a cop. Wings are among the most recognizable motifs of the fantasy genre. The ears can also be turned into wings, as has been done with this erect crested penguin (on a real erect crested penguin, the ears would show elaborate feathering, but not wings).

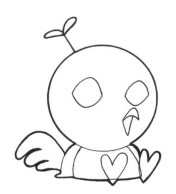
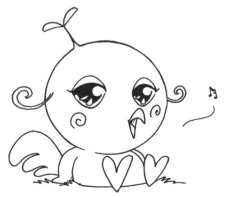
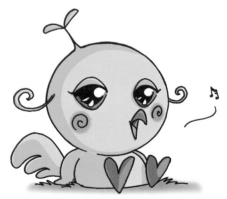

Baby Bird Chibi-Special Talent: Singing

This songbird can do requests, as long as all the lyrics are "tweet." The big head and small, chubby body are based on the proportions of a baby.

Chibi Monsters with Magical Powers!

Just because they're small, it doesn't mean they're not powerful. Chibi monsters are often the servants of their human owners in the same way that hawks were the trained servants of knights. The magical chibi possesses outsized powers, which can be used for good—or evil. You can usually tell if the chibi is good or not by the look of its owner: Evil owners have evil chibis. The reverse is also true. Of course, bad guys can kidnap good chibis and use them for their nefarious purposes. (Hey, no one said life's fair.) The magical powers and amazing forces that are commanded by the chibi can be of titanic size, dwarfing the chibi that releases them. Let's take a look at some of the special effects that make these chibis so exciting.

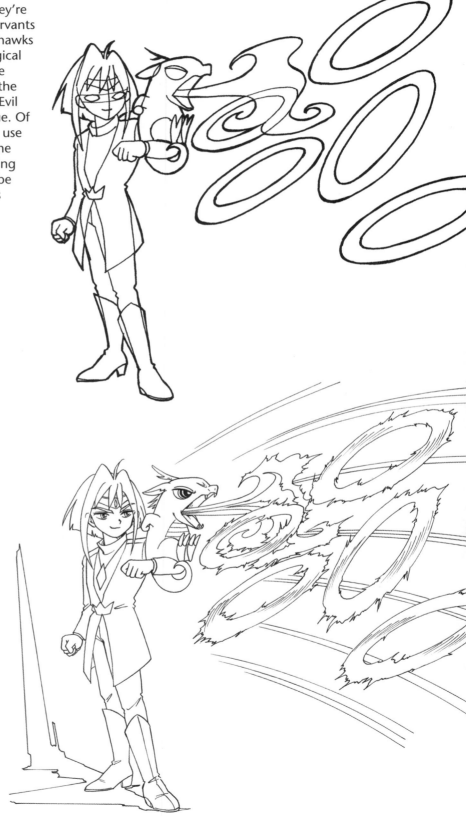

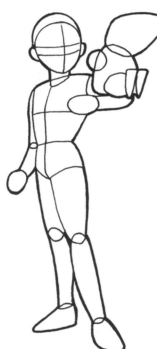

Fire-Shaper

Fire is always a good effect. The colors are brilliant, and they glow with intensity. But it's not enough to blow flames—that's been done since dragons have been around—you've got to dig a little deeper and get creative. This little creature, based on a dragon, can spew flames in any shape, virtually lassoing its opponent in a ring of fire. You've got to admire a bad guy who can do that.

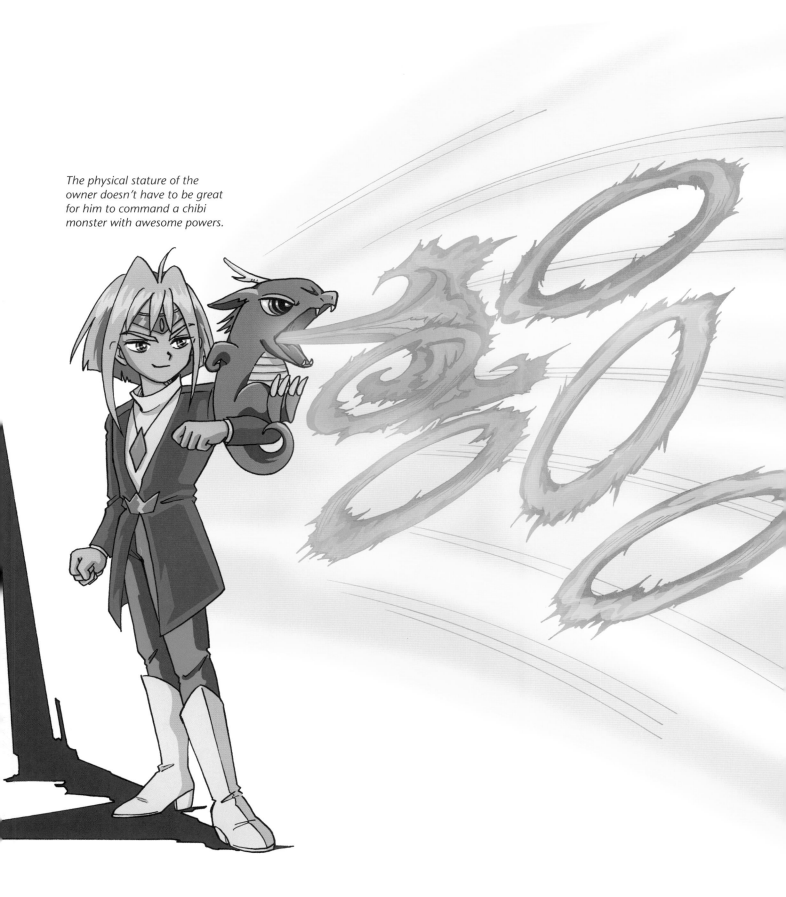

The physical stature of the owner doesn't have to be great for him to command a chibi monster with awesome powers.

Spike-Sprayer

This little porcupine-type chibi is no ball of laughs—especially if you're on the receiving end of the toss! The chibi should rotate as it travels in the air, shooting spikes from its body. No sooner does one spike shoot off than another one grows in its place. This boy character is on the side of good, as you can see by his earnest expression and costume (bad guys dress flamboyantly; good guys are more down to earth). After this chibi saves the day, you might be tempted to give it a hug. Don't—unless you have a good set of tweazers and a lot of free time.

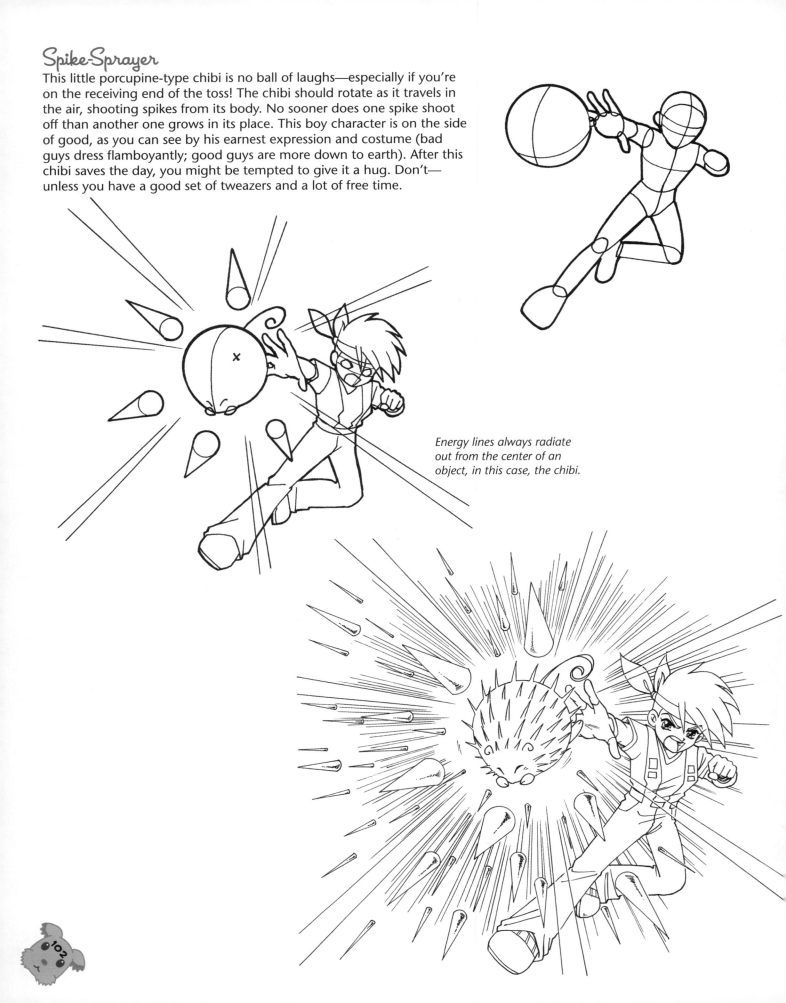

Energy lines always radiate out from the center of an object, in this case, the chibi.

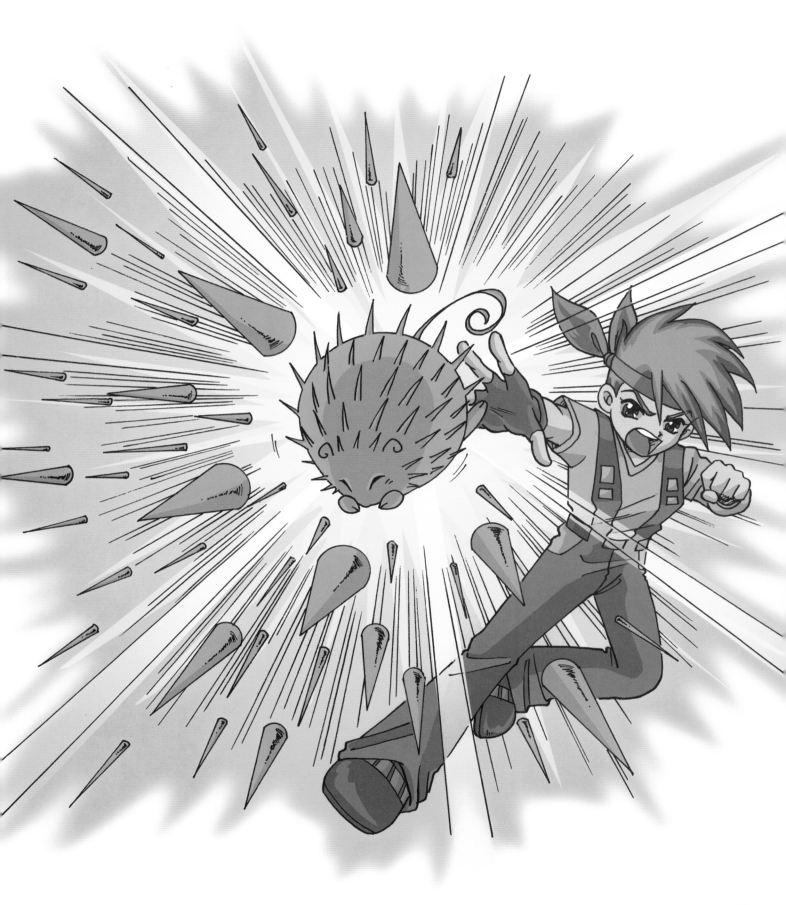

Storm-Starter

This is not a good chibi to bring to a picnic. With its special powers, it can attract all the electrical currents from the sky, and redirect them to destroy the enemy with explosive force. Rather than simply illustrating one lightning bolt, we again dig a little deeper into our creative well and come up with a fresh application for this classic special effect. The chibi draws electrical charges from the sky, like a super-conductor. Note that the horns of the chibi are the focal points that draw the electricity to it. The chibi's expression shows that its strength is being sapped by this exhausting work. But its evil owner doesn't care.

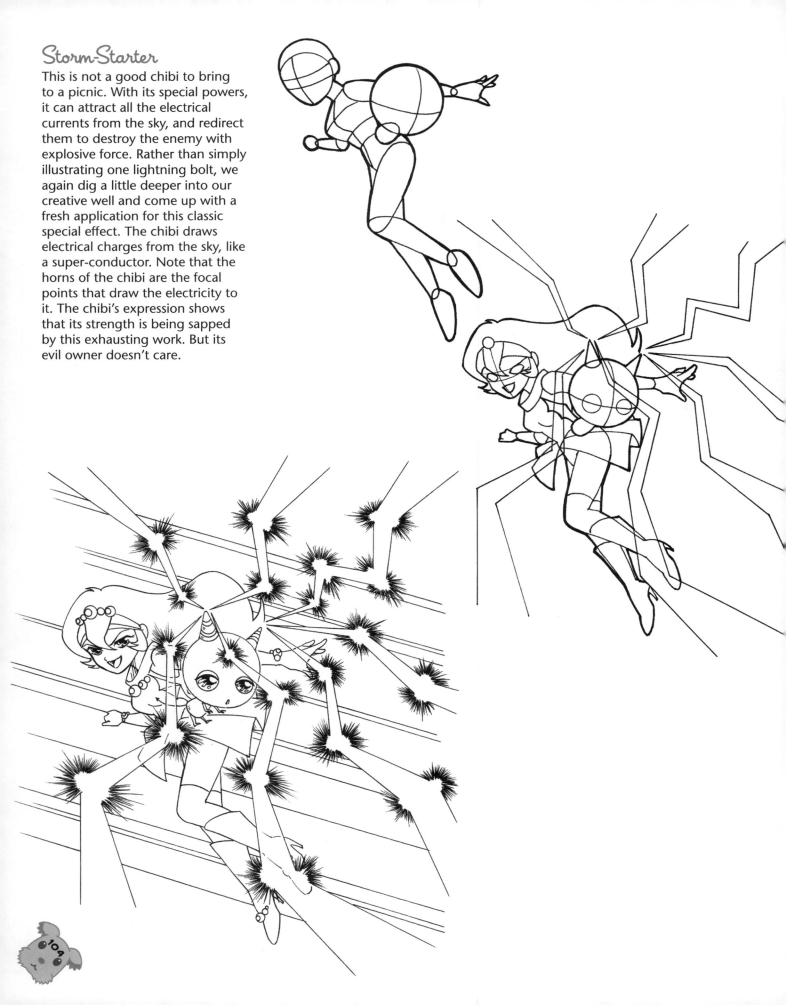

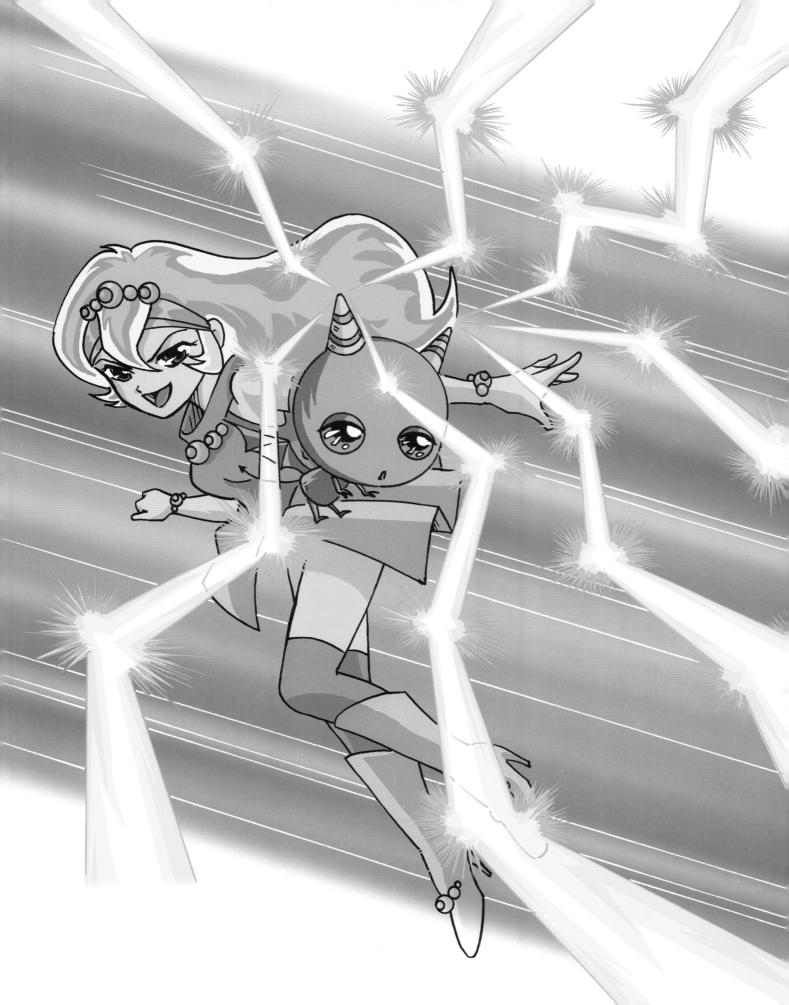

Hurricane-Maker

When panicked, this frightened little chibi unwittingly sets off a chain reaction that causes monsoon-like winds capable of devastating an area miles wide. Leaves and brush go flying into the air. The wind is drawn to look like spokes on a bicycle, with the chibi at the center. It's important to add "blurs" to the lines, to give the feeling of motion. Projections are emitted from the bird's eyes in the form of overlapping circles that widen out as they travel towards the reader. This poor little fellow doesn't intend to cause any harm. He's just having a knee-jerk reaction. He can't help it if he's a chibi with a panic disorder. He's as dangerous to his owner as he is to his enemies!

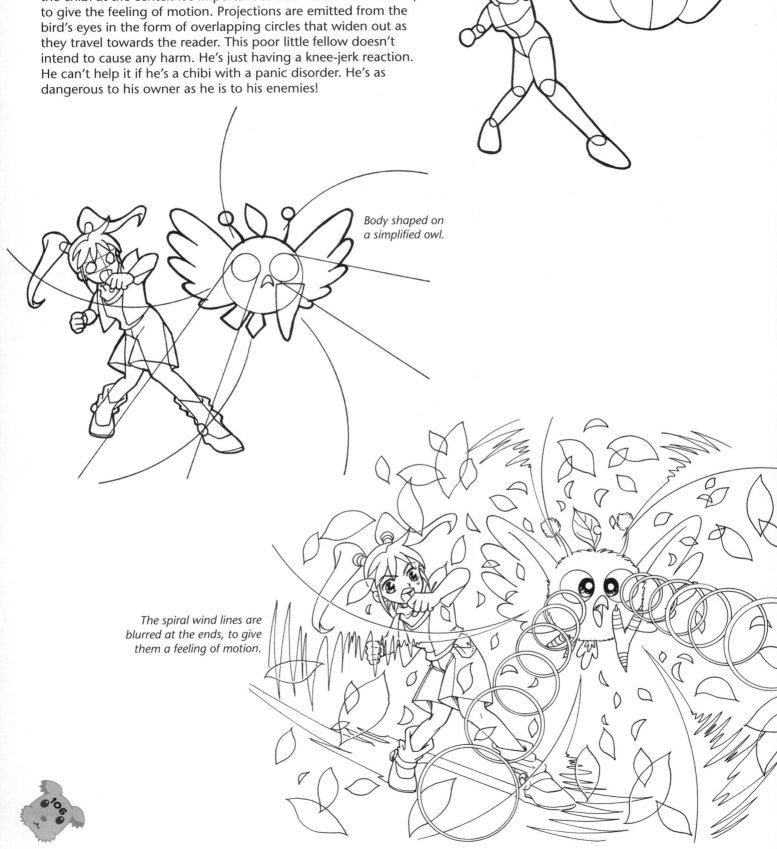

Body shaped on a simplified owl.

The spiral wind lines are blurred at the ends, to give them a feeling of motion.

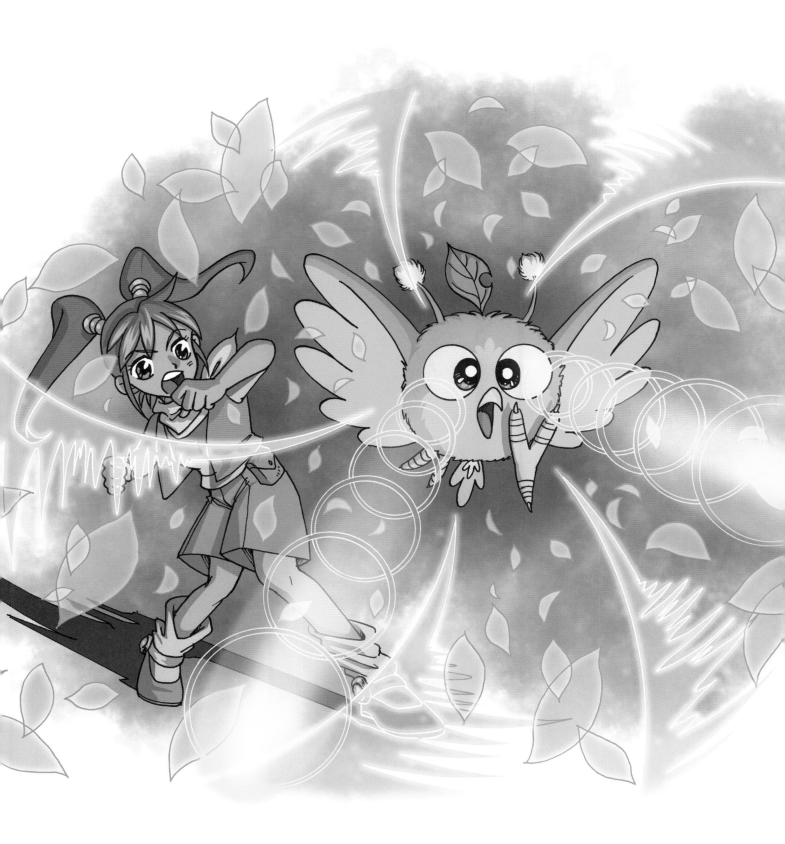

Magical Chibis without Human Owners

Not all chibis with magical powers are teamed up with humans. Some, like faeries and mermaids, use their powers to help friends, thwart enemies, and protect their domain, whether it's a forest clearing or an undersea kingdom.

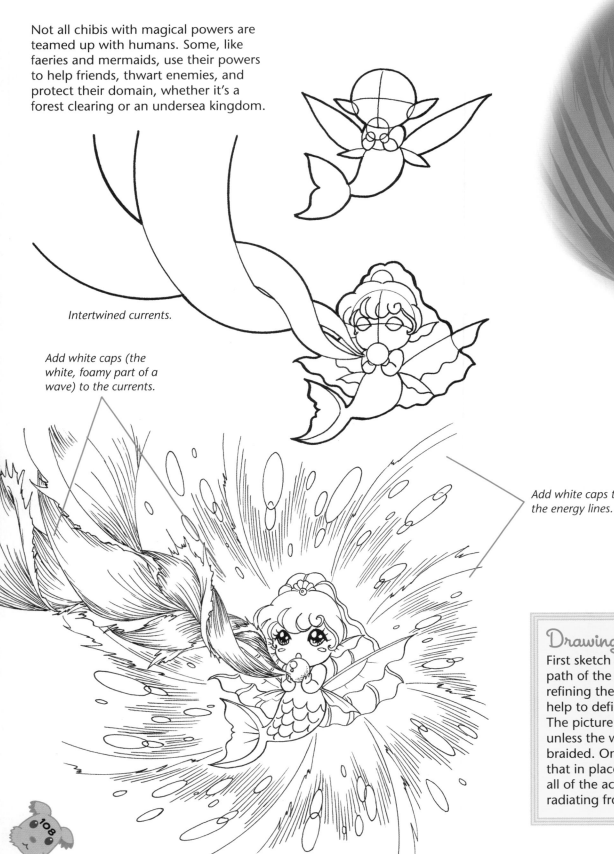

Intertwined currents.

Add white caps (the white, foamy part of a wave) to the currents.

Add white caps to the energy lines.

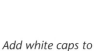

108

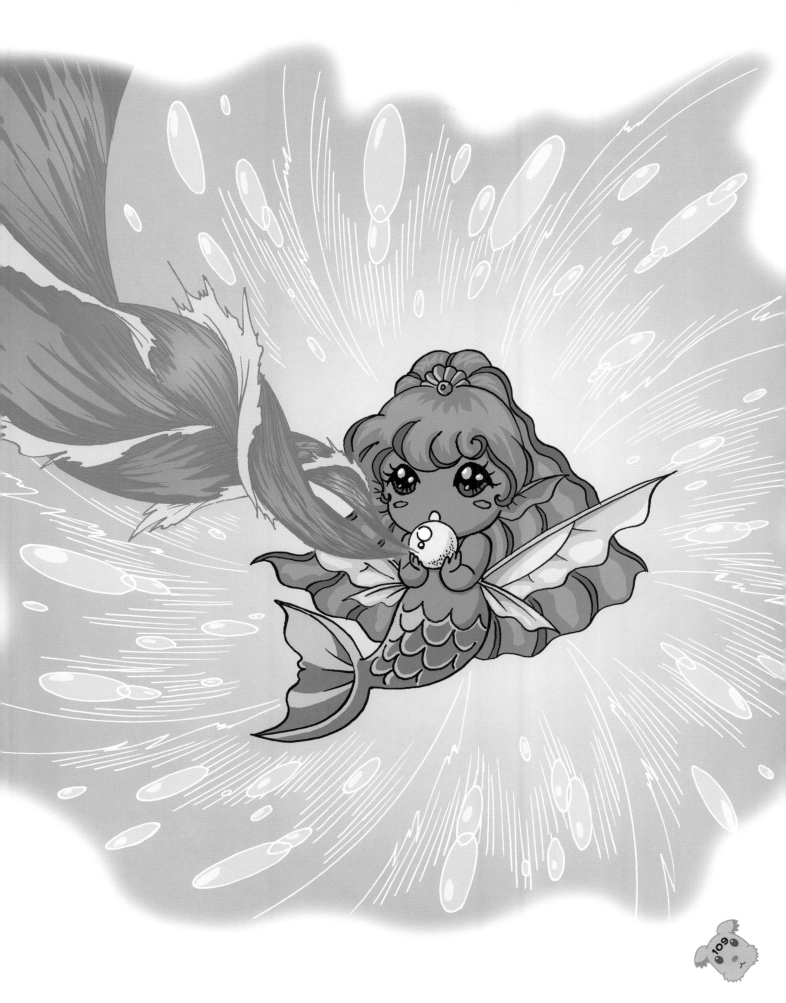

Fairies

As you can see, he doesn't like being called "shorty." Spirals, as well as swirling and braided lines, are pleasing to the eye. They allow the eye to travel as if on a roller-coaster ride. But to make the design truly compelling, the size of the spirals must increase in size, otherwise they would look static. This only works if the spirals are traveling toward the reader. The projecting spirals have the immediate effect of involving the reader, who senses the impending impact, as if he were going to be hit by the special effect. Notice how the energy lines that radiate outward from the character make a good backdrop, no matter what the actual special power turns out to be.

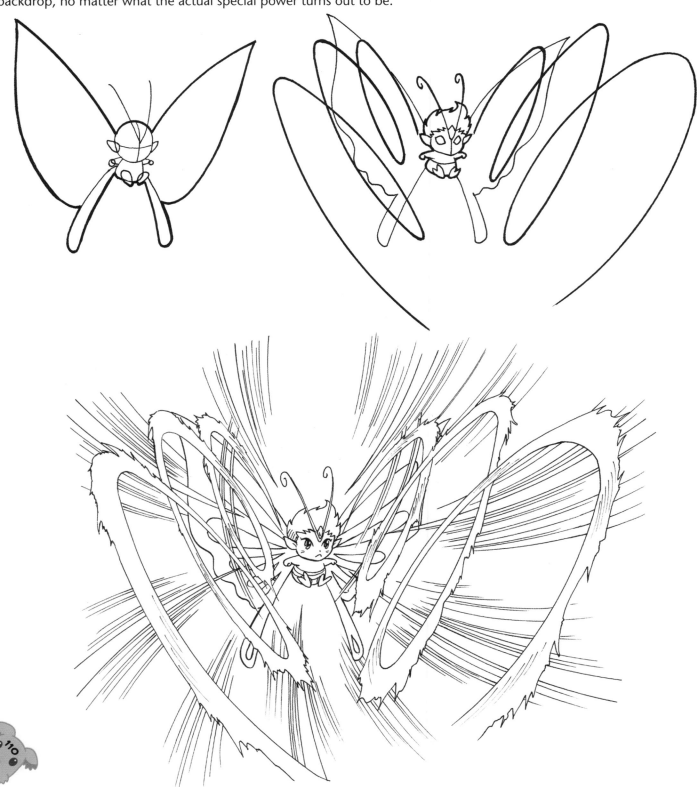

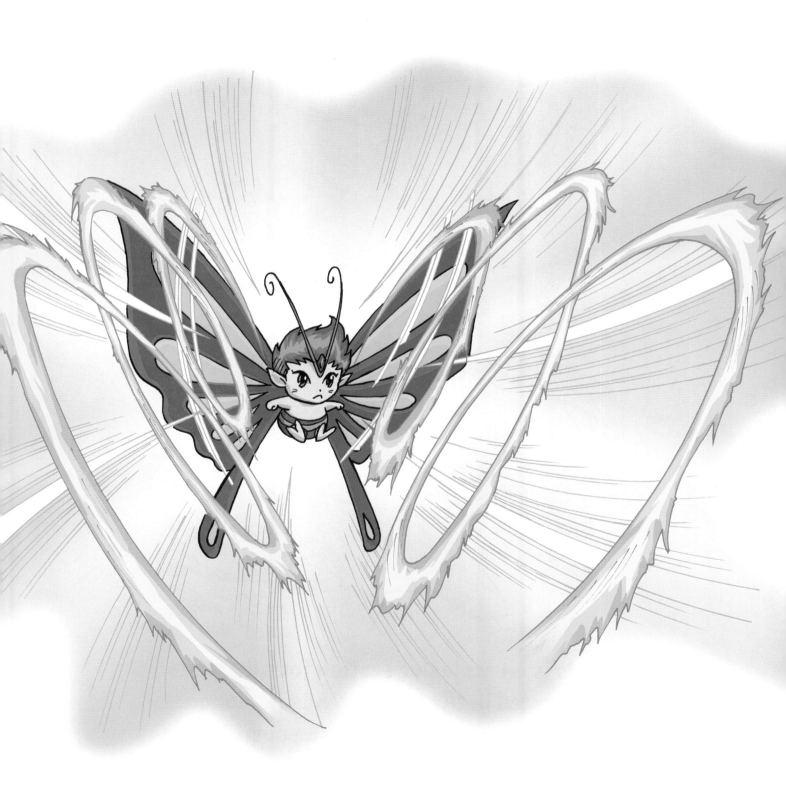

SUPER-STYLIZED CHIBIS

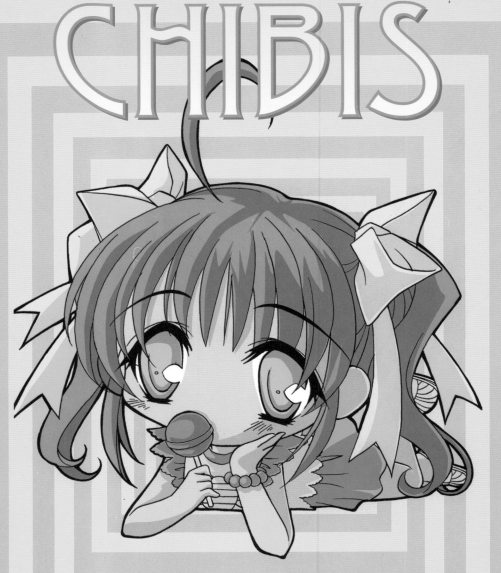

This is an exclusive section for all artists interested in the latest trends in manga. The new wave of chibi taking over Japan is the "super-stylized chibi." For the first time, I am bringing this new style straight from Japan to America, so you can be as blown over by it as I was.

Little Lady

We begin with a sweet and pretty super-stylized chibi. Up until now, most chibis you've seen have been delightfully silly and funny. They have been primarily broad characters used to get laughs. But in Japan, this new style of chibi is different from the standard chibi in that they are elegant, subtle, with big heads and slightly elongated bodies. Their faces are extremely wide, which allows ample room for their dazzling eyes. These chibis can emote complex feelings in their poses and expressions. They are also costumed in ornate outfits decorated with numerous flounces.

When setting out to create a new character, it's good practice to first list the traits that will most aptly describe her. That way, you can target a specific personality. When listing the traits of this little lady, we have:

- Well mannered
- Loves flowers
- Loves cute things
- Kind
- Cries often

Translation: "Eek! I'm so embarrassed!!"

Initial Sketches

Beginning artists often suffer from inertia— the feeling that you just can't get started. That blank piece of paper can be intimidating. Beginners hesitate to put something down on paper because it might come out wrong. And once they do put something down, they feel that they've got to stick with it and make it work. The truth is that while you do have to start somewhere, you absolutely *do not* have to stick with your first sketch. Often times, the first sketch gets the inertia out of the way, so that you can go on to do a good second sketch, or third sketch, or fourth. Remember, no one knows how many times it took you to make a cool drawing. Only the final drawing counts. So don't be hard on yourself if you need to go through several drafts before you get a keeper.

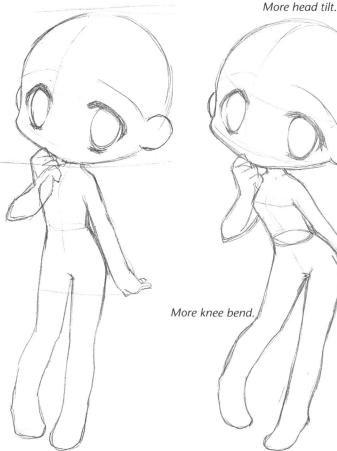

More head tilt.

More knee bend.

More hip tilt.

In this case, the pose, although sweet, is lacking something. It should be a little more exaggerated, don't you think? Let's see what happens when it's adjusted.

To emphasize her femininity, her knees are turned slightly inward, and her hand is brought to her chin. She bends deeper at the waist, rather than standing rigidly. These are minor changes, but don't they add up to a more attractive pose?

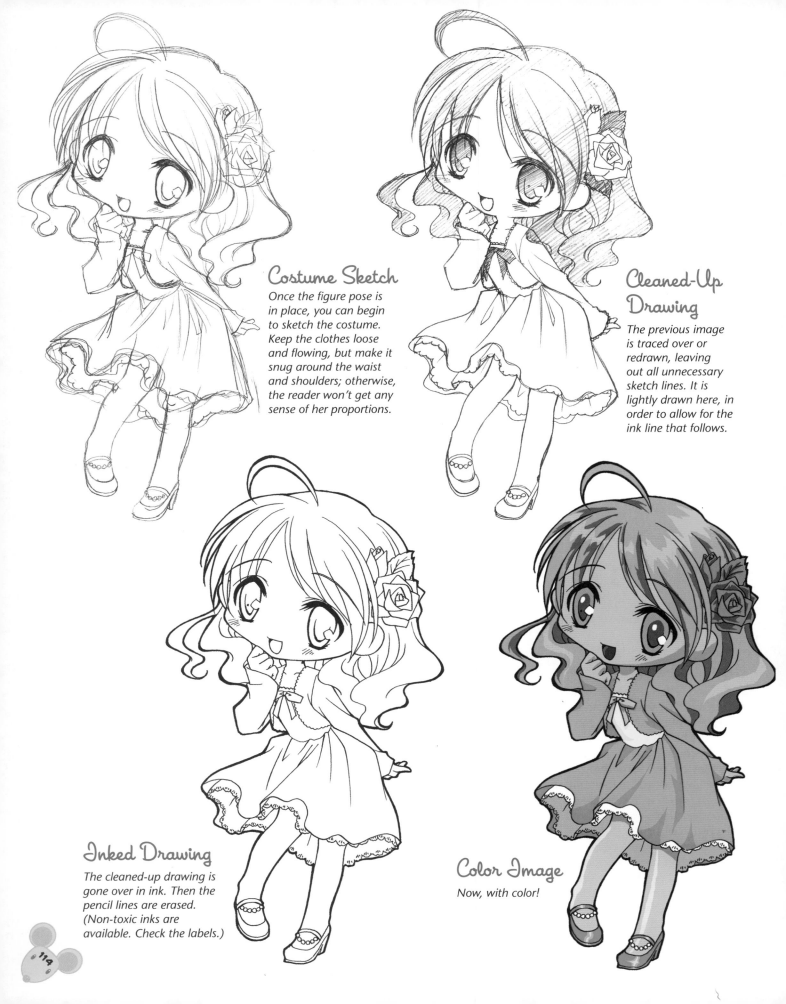

Costume Sketch

Once the figure pose is in place, you can begin to sketch the costume. Keep the clothes loose and flowing, but make it snug around the waist and shoulders; otherwise, the reader won't get any sense of her proportions.

Cleaned-Up Drawing

The previous image is traced over or redrawn, leaving out all unnecessary sketch lines. It is lightly drawn here, in order to allow for the ink line that follows.

Inked Drawing

The cleaned-up drawing is gone over in ink. Then the pencil lines are erased. (Non-toxic inks are available. Check the labels.)

Color Image

Now, with color!

Super-Stylized Chibi Boy

These super-stylized chibi characters have the features placed very far down on the face. The eyes remain huge and are deeply wedged into the upper eyelids. This character is a typical boy. He is mischievous, likes sports, gets cuts and bruises, has a bad temper, but is also capable of kindness and friendship. Some other character traits:

- Thick brows
- Plays rough
- Acts before thinking

More head tilt.

Translation: "Aurrgghhh!!!"

なんだと、！？！

Figure Sketch—First Attempt

Good idea for a pose: nice hand gesture, but (there's always a "but"!) there's not enough attitude in the body language. Try again.

Thumb comes at viewer.

More hip tilt.

Figure Sketch—Second Attempt

Much better. Now he's a little cocky, which suits his character better. (A tilt of the hips is always a good place to get more attitude into a pose.) Note that this pose is broken up into three parts: the head tilts forward (as indicated by the center guideline); the torso tilts back (also indicated by the center guideline); and the legs go straight down, vertically. The "thumb's up" sign comes right at us, and therefore, that arm is foreshortened. Be careful not to cover his eye with his thumb!

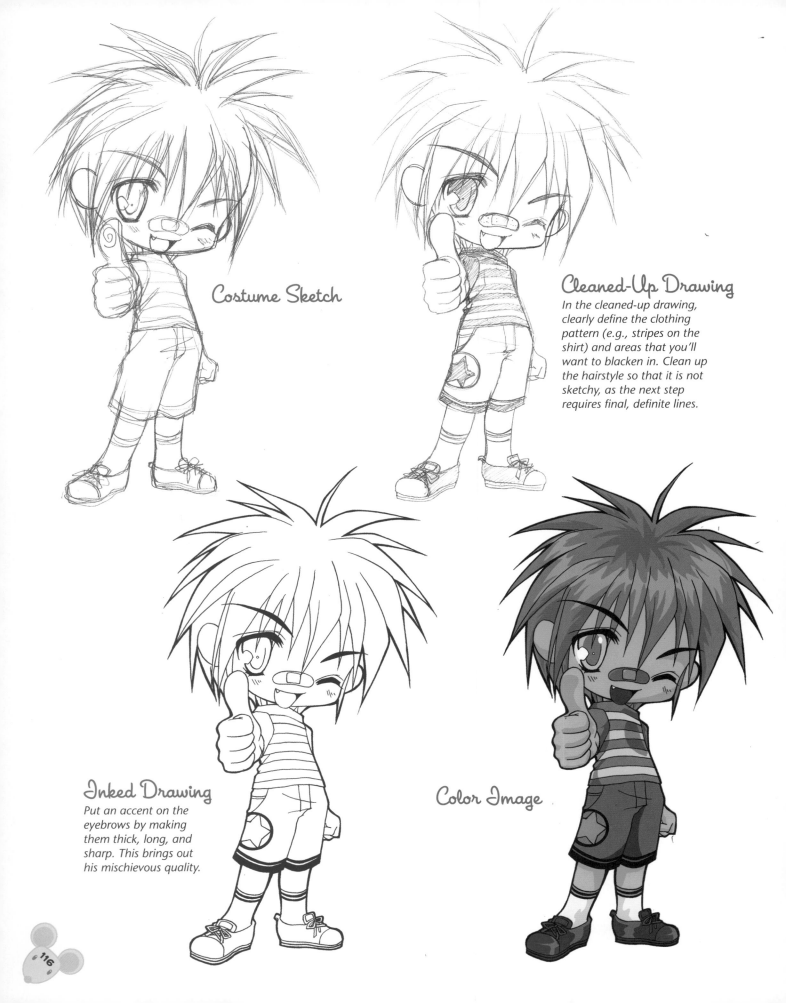

Costume Sketch

Cleaned-Up Drawing

In the cleaned-up drawing, clearly define the clothing pattern (e.g., stripes on the shirt) and areas that you'll want to blacken in. Clean up the hairstyle so that it is not sketchy, as the next step requires final, definite lines.

Inked Drawing

Put an accent on the eyebrows by making them thick, long, and sharp. This brings out his mischievous quality.

Color Image

Super-Stylized Cat-Girl

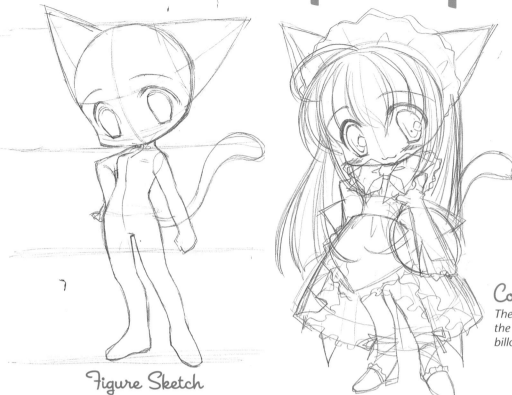

The super-stylized chibi cat-girl does not have a strong cat-like appearance. Instead of wearing a midriff and short skirt, which is typical of regular cat-girl characters, she is draped in lacey, layered clothing, which feminizes her and makes her seem less wild. But she does have the subtle, telltale cat trait of a split upper lip. And, of course, she has cat ears and a tail. But other than that, she is a dainty little girl.

Figure Sketch

Costume Sketch

There is a tight band around the waist, while the dress billows at the bottom.

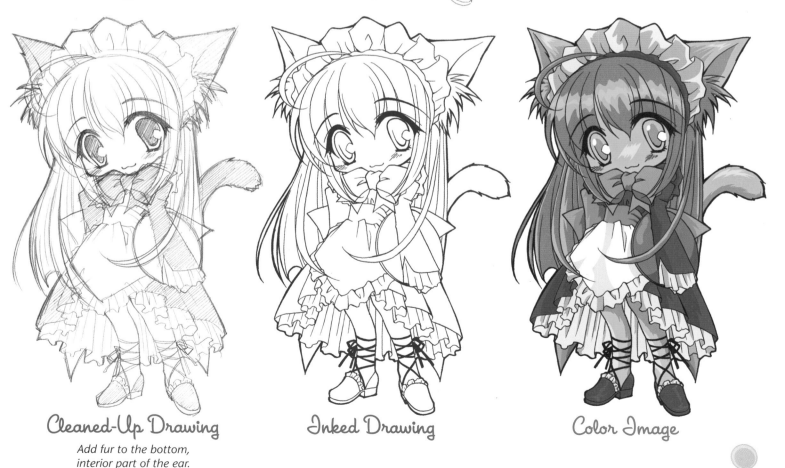

Cleaned-Up Drawing

Add fur to the bottom, interior part of the ear.

Inked Drawing

Color Image

Super-Stylized Rabbit-Girl

People love to see characters emote deep feelings. Although it might seem counterintuitive, readers love to see sad characters, because it makes them so sympathetic. It gives them that prized "Awww" factor. That doesn't mean that your character should be depressed all day, sitting in bed, watching soaps and eating ravioli out of a can. But moments of poignancy help to connect the reader to the character on a gut level. The ears are flopped over to mirror her downtrodden emotions; likewise the head is tilted down.

Figure Sketch

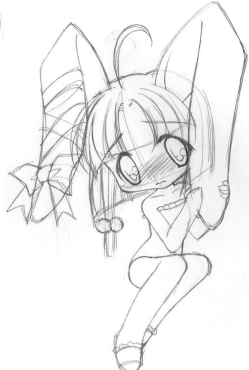

Costume Sketch

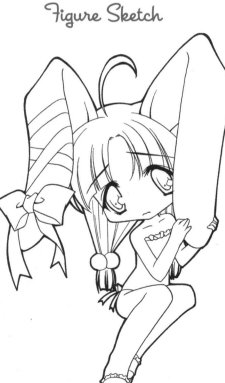

Cleaned-Up Drawing

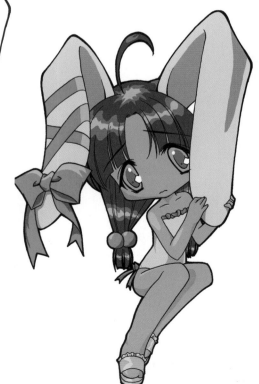

Inked Drawing

No earrings on rabbit ears,
but a little ribbon makes
a nice decoration.

Color Image

Chibi Troublemaker

To be perfectly honest, not *all* super-stylized chibis are sweet and nice. And to prove it, here's one that's a little devil. Her eyelashes have been given a wicked look by lifting them up at the edges. She has a pointed ear, a long, thin tail, and bat wings. Stay away from lacy or pretty clothes. Her costume should be a bit on the skimpy side. Note the posture: wicked and evil characters bend forward at the waist, as if they were crouching and hiding something. Good characters stand upright and true.

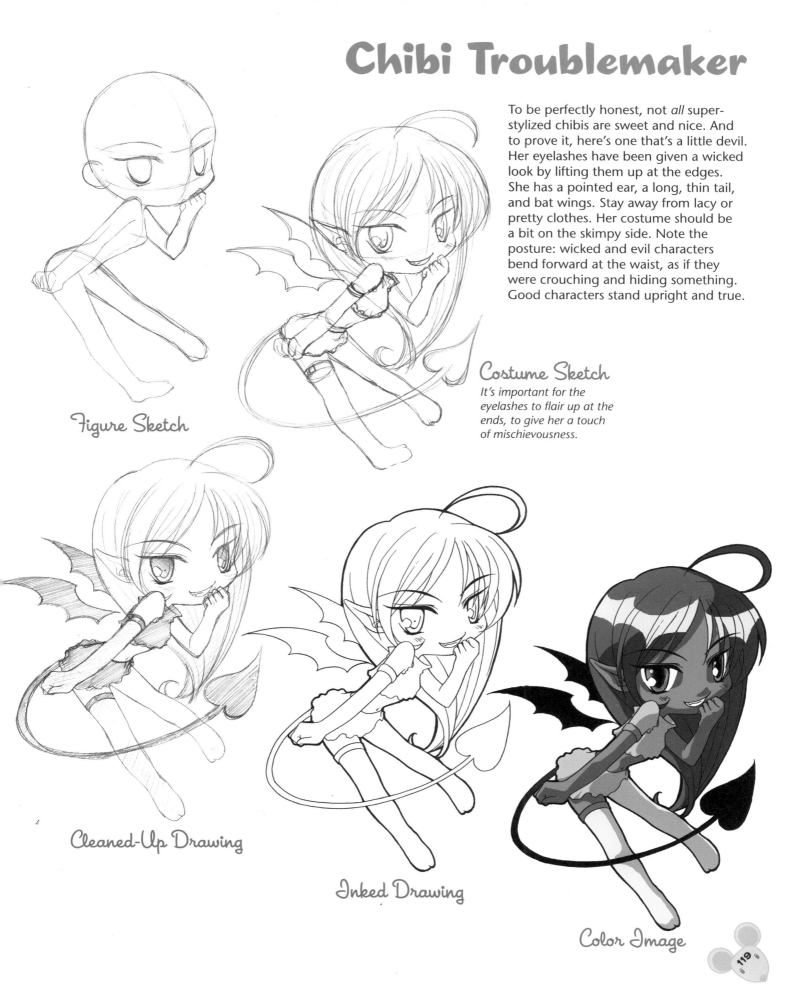

Figure Sketch

Costume Sketch

It's important for the eyelashes to flair up at the ends, to give her a touch of mischievousness.

Cleaned-Up Drawing

Inked Drawing

Color Image

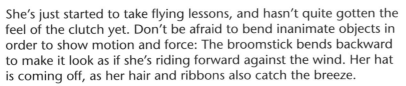

Witch-in-Training

She's just started to take flying lessons, and hasn't quite gotten the feel of the clutch yet. Don't be afraid to bend inanimate objects in order to show motion and force: The broomstick bends backward to make it look as if she's riding forward against the wind. Her hat is coming off, as her hair and ribbons also catch the breeze.

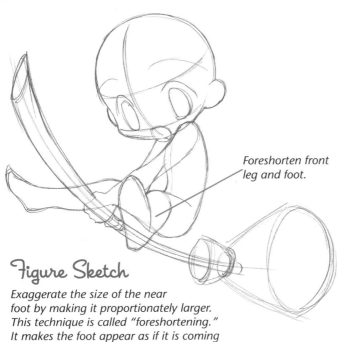

Foreshorten front leg and foot.

Figure Sketch

Exaggerate the size of the near foot by making it proportionately larger. This technique is called "foreshortening." It makes the foot appear as if it is coming toward the reader. The broomstick bends back, due to inertia.

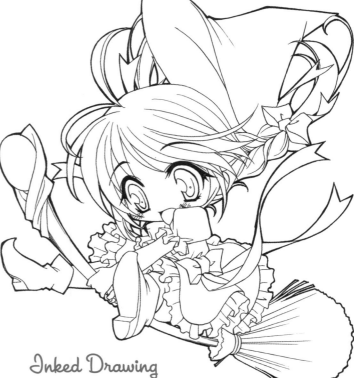

Costume Sketch

Notice how the hem of the dress flows smoothly, like hills and valleys, over and around her legs and the bristles of the broom. Make undergarments longer than the dress so you can see the flounces underneath.

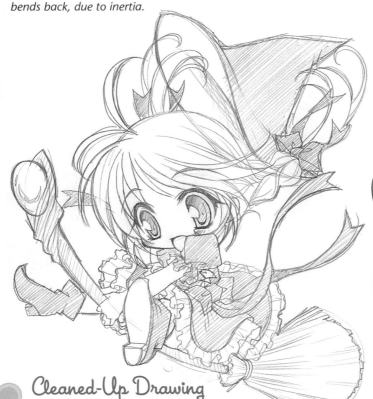

Cleaned-Up Drawing

Inked Drawing

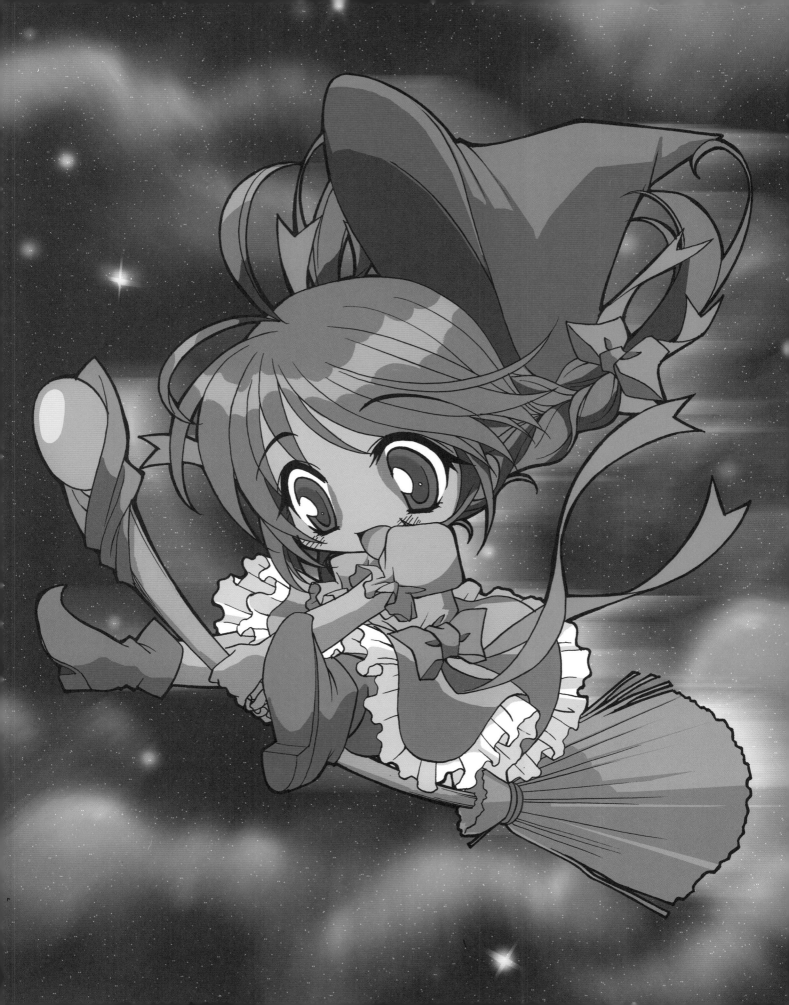

Little Angel

The angel's eyes are big, bright, and round. They have none of the sharpness of the devil character's eyes. However, she can have pointed ears, which show that she is other than human—a charmed being. Her wings are feathered (if they were of the dragonfly variety, it would turn her into a fairy).

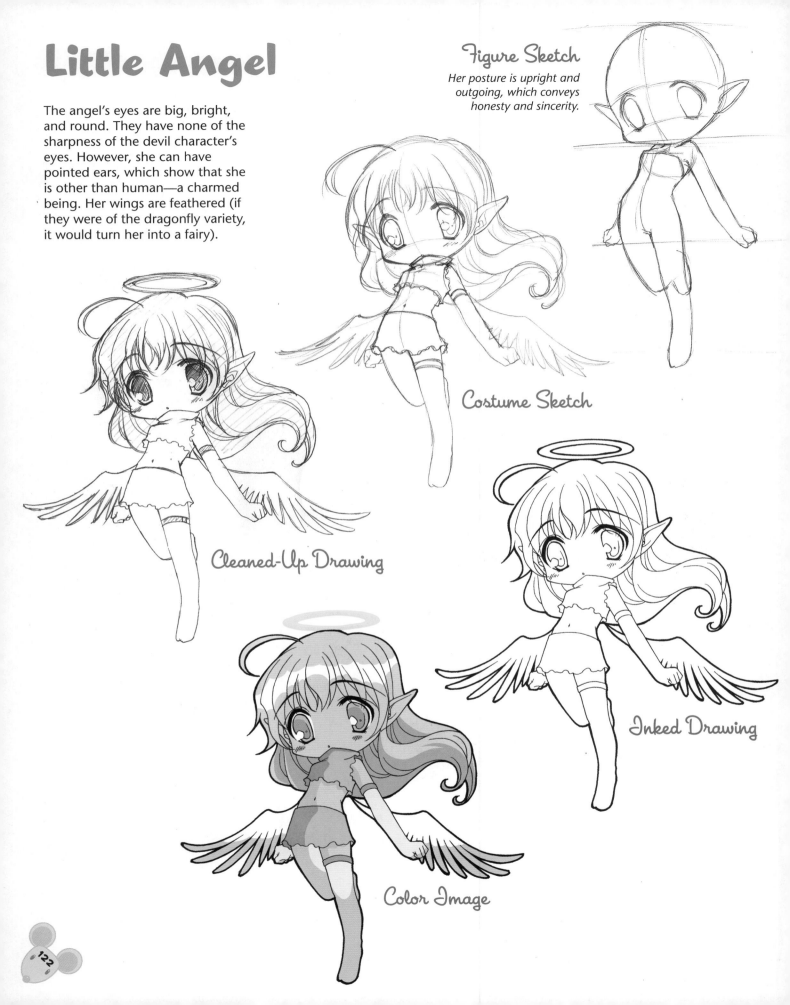

Costume Sketch

Cleaned-Up Drawing

Inked Drawing

Color Image

Wishing on a Star

When you have a super-stylized, innocent little chibi like this one, you can really pile on the clothing. It makes her look more childlike and sweet. Why do the added layers of clothing have that effect? Let's analyze it: Whenever you see a small child wearing clothes that are obviously too big for him or her (hand-me-downs, for example), it makes the child seem smaller, and a little bit confused, in an endearing way. And so it is with chibis. Accessorize her outfit with a bow, some lace, a pompom, and a shawl.

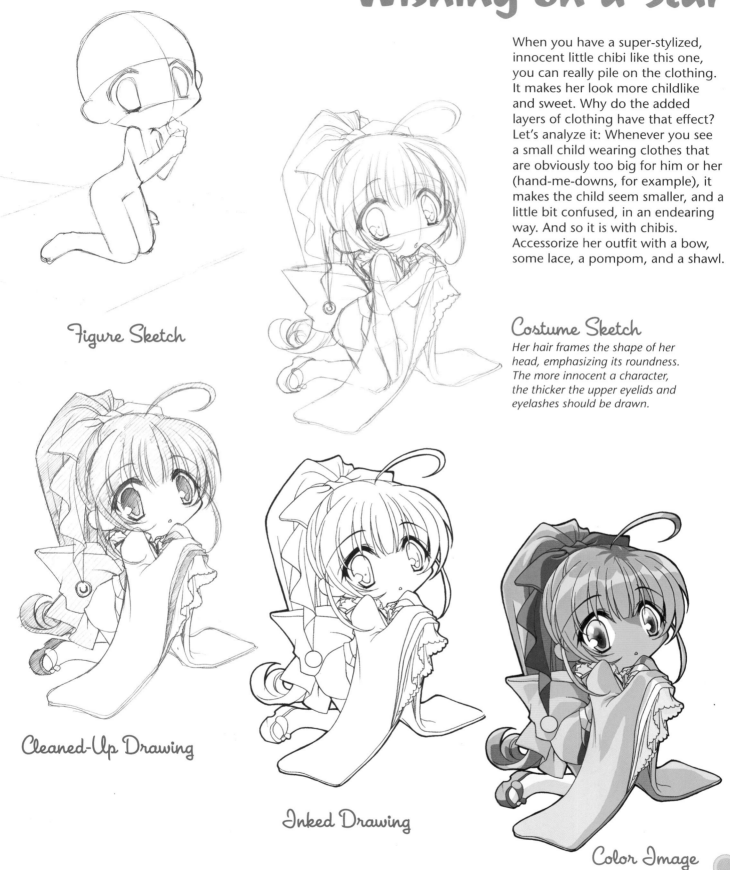

Figure Sketch

Costume Sketch

Her hair frames the shape of her head, emphasizing its roundness. The more innocent a character, the thicker the upper eyelids and eyelashes should be drawn.

Cleaned-Up Drawing

Inked Drawing

Color Image

Candy Girl

Here's a classic little girl pose: lying on the stomach with one knee bent, foot in the air. Her eyes are extra-big, even by extra-big standards! The emphasis is on the oversized, round head, with the wide face and large forehead. And all the stuff of little girls is apparent: ribbons in the hair, bracelet, lollipop, frilly outfit, and sandals. A curl of hair on top lends an accent, and breaks up the outline of her head nicely, which would otherwise be a circle.

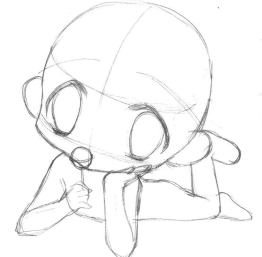

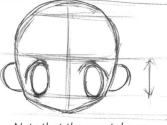

Note that the eyes take up almost all the area of the bottom portion of the face.

Figure Sketch

Note that the eyeballs are drawn larger on top and smaller at the bottom.

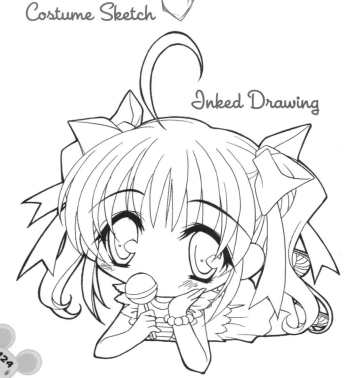

Curl.

Ribbons.

Costume Sketch

Cleaned-Up Drawing

Inked Drawing

Color Image

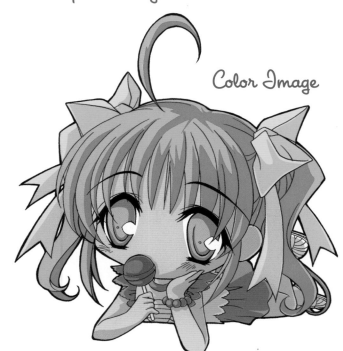

Serious Student

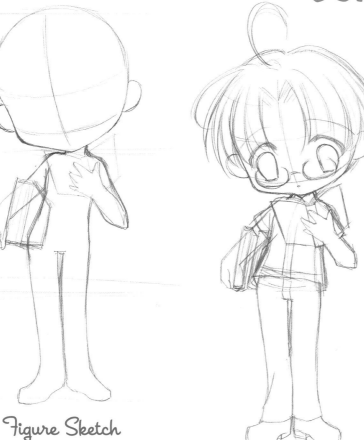

Bookish characters are used for humorous relief. They are generally portrayed as being a little out of step socially, oblivious to their surroundings. Only the honk from an oncoming car can wake this kid from his trance. Studious characters wear glasses, not contacts and never sunglasses. They have slight builds and don't wear anything trendy.

Figure Sketch

Costume Sketch

Looking at this drawing with a critical eye—always an important practice for artists—it seems that the character's proportions are becoming too "normal." He's long enough that he's in danger of looking like a regular-size kid, instead of a chibi. While the head is a perfect chibi head, the body needs to be adjusted. But how? If he's simply shortened, he'll be smaller, but will still have a normal person's proportions. What shall we do? Can you figure out a solution?

Cleaned-Up Drawing

That's better. Can you see the difference? What did we do? While his legs remain the same, his torso has been shortened. And his head has been lowered so that the book partially covers his face, making it look as though he were really sinking into it. I never knew trigonometry could be so fascinating.

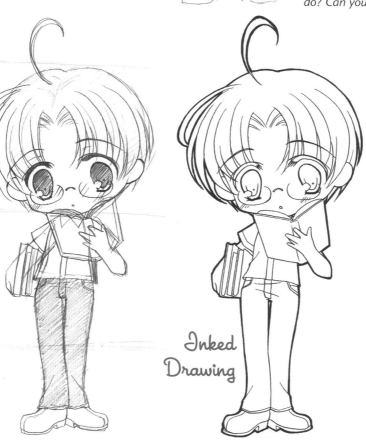

Inked Drawing

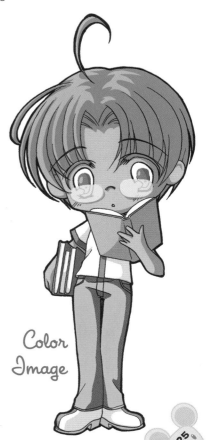

Color Image

Chibi Hero Fighter

If I were in danger, about to be attacked by giant, fire-breathing iguanas, and I saw this little guy flying to my rescue, I'm not so sure I would be overly optimistic about my fate. Nevertheless, this type of character turns out to be a highly skilled and formidable foe. Don't bulk up his frame, or give him big arms. That stuff is really beside the point. He's not a super-fighter in the regular sense of the word. Instead, he's more of an avenging angel: fast (zipping all around his enemies like a bee that can't be swatted), clever, and relentless. Think David battling Goliath.

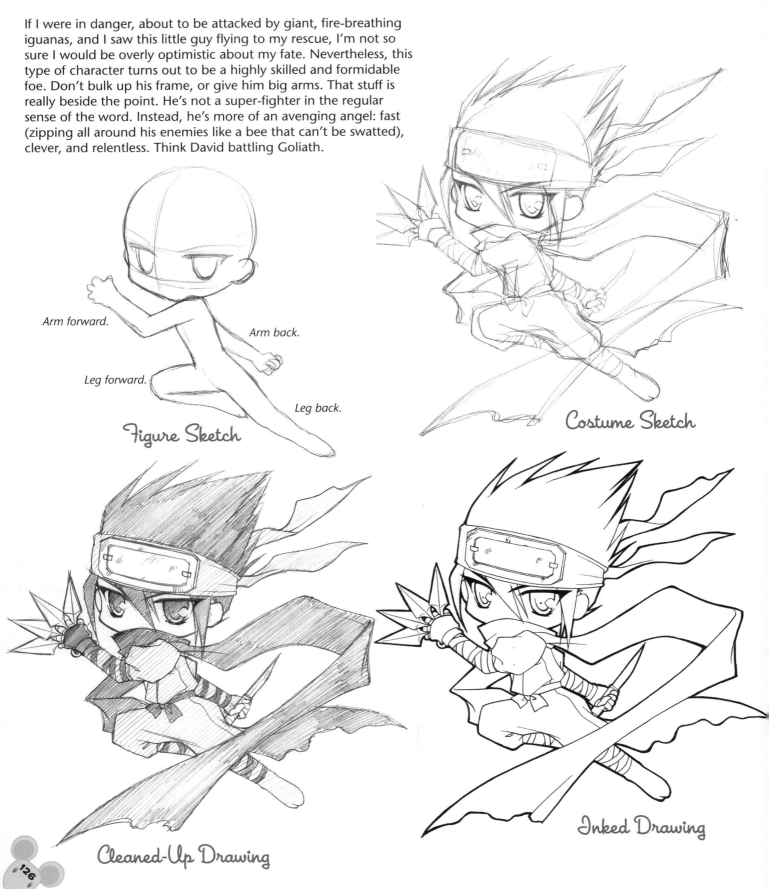

Arm forward.

Arm back.

Leg forward.

Leg back.

Figure Sketch

Costume Sketch

Cleaned-Up Drawing

Inked Drawing

Flying Pose Hint

Flying poses are like
running poses: the arm
and leg on the same side
go in opposite directions.

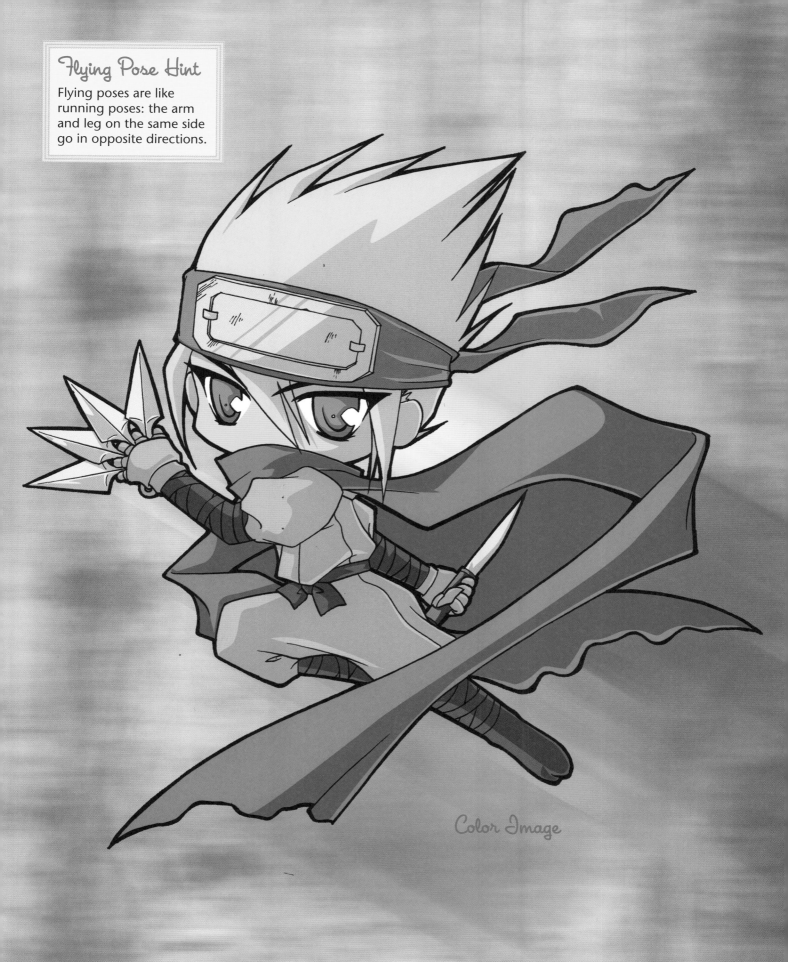

Color Image

Tropical Girl

When drawing girls, pay special attention to the curves. In order to emphasize the roundness of the hips, you must make the waist small, so that the hips stand out by contrast. Placing the knees together is an appealing and feminine pose. Flip one foot up to make your character especially playful. Props, like this hibiscus flower and pineapple, conjure up a tropical mood. The island-style skirt, sandals, and flower tattoo make her look like a native. The downward tilt of the head is a coy look that's useful when your character is trying to be charming, or a little flirtatious.

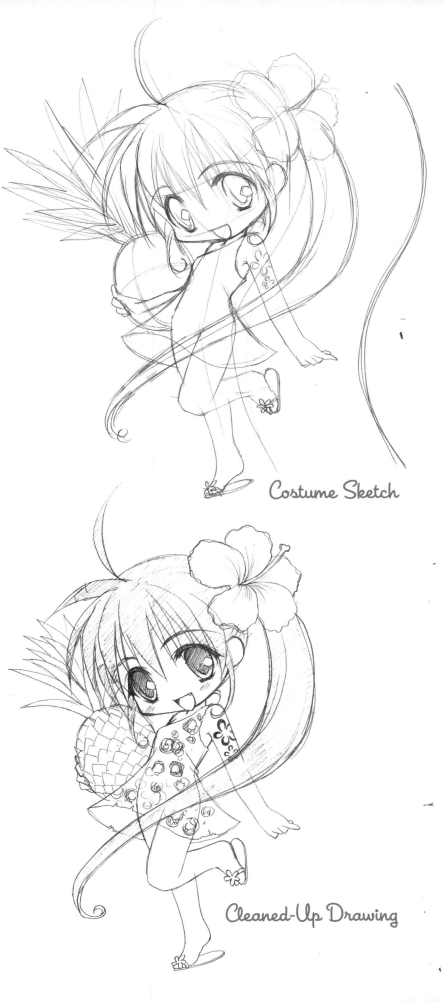

Costume Sketch

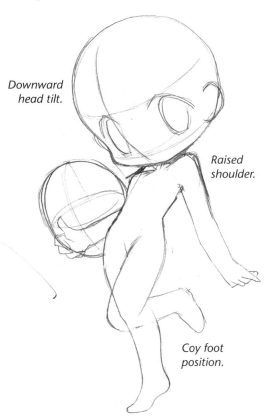

Downward head tilt.

Raised shoulder.

Coy foot position.

Figure Sketch

Draw the arm through the pineapple, so that you can get the right placement of the hand.

Cleaned-Up Drawing

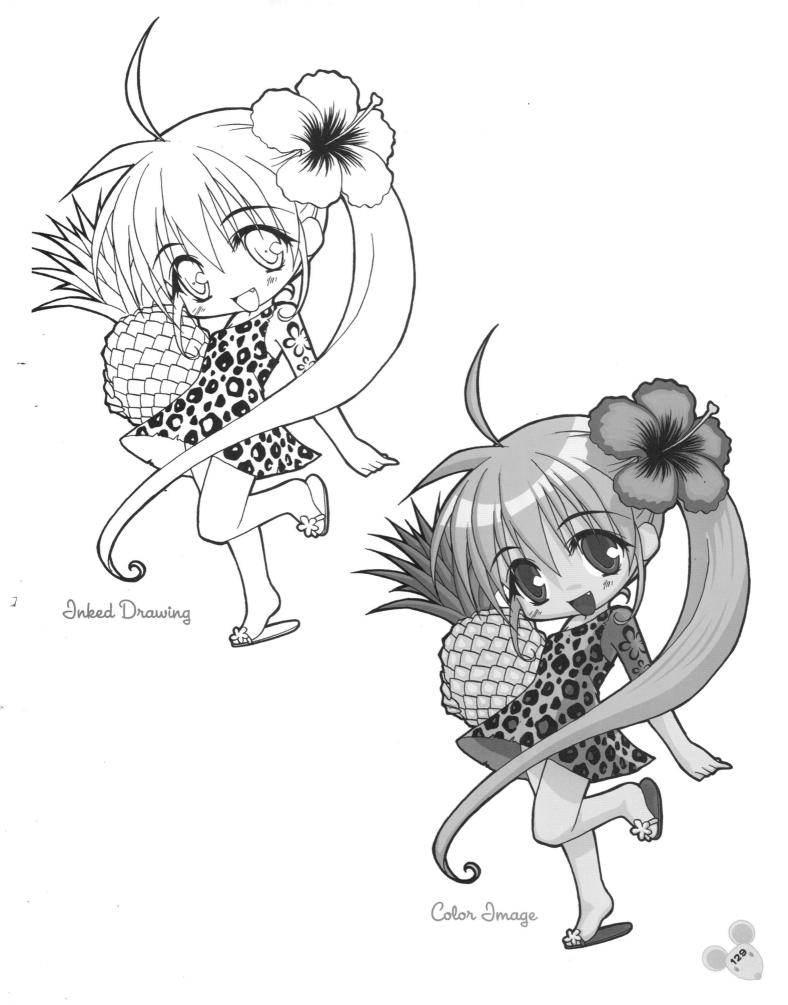

Inked Drawing

Color Image

129

Super-Deformed Characters

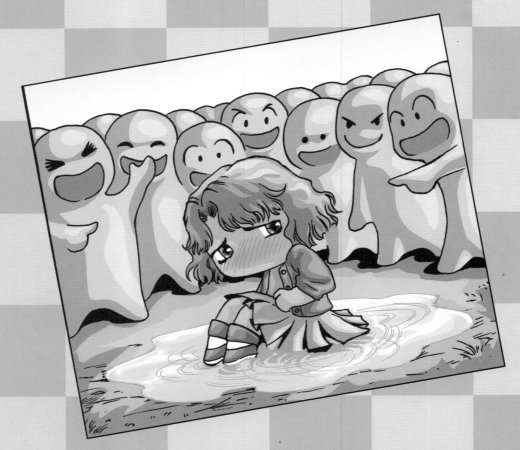

The term "super-deformed" refers to the sudden transformation of a regular-sized manga character into a chibi, in order to experience a brief, broad emotion and, more often, comic relief. Then, in the next panel, the character immediately resumes his or her normal form. It's a hilarious device that is used throughout manga, but especially in shoujo (girls' comics) and shounen (boys' action comics).

Temper Tantrum

Turning into a complete and utter brat is a very funny way to trigger a super-deformed event. This little princess has a catastrophic meltdown when things don't exactly go her way. Gushers of tears spring from her eyes. Her mouth gets huge and her lips get all wiggly. She shrinks in size to chibi height, and also gets chibi-style chubby, which makes her look all the more like a bratty baby. Immediately after her rant, she returns to normal size, with the remnants of her tears still apparent on her cheeks.

Drawing Hint

The key to using super-deformed characters is timing, that is, knowing when to make the transformation in order to capture the character at the height of his or her emotion. The super-deformed character must, by definition, have a big reaction—nothing ordinary will do the trick. It is the force of the character's reaction that causes the deformation to occur.

When Two Characters Go Super-Deformed at the Same Time

A character who super-deforms can cause such a strong emotion in the other character in the panel that it causes her or him to super-deform, too. The character that is reacting to the first character must react with a different expression. For example, if one character gets so angry that he super-deforms, the other character might super-deform by becoming stunned. And remember, super-deforming is meant to depict a moment in time; don't hold it over for a second panel.

Note that the girl straightens out her hair in the third panel, which shows that she is recovering from what happened to her in the second panel.

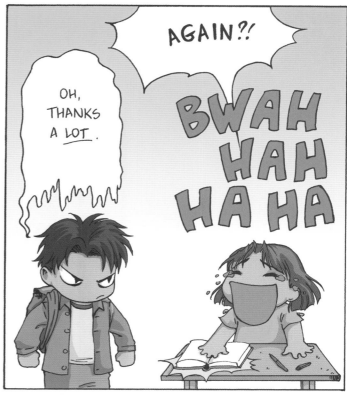

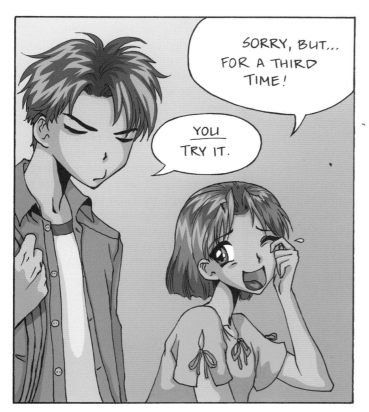

Here's another good example of two characters locked in a super-deformed action/reaction. Note how small they get as they shrink down to chibi size. Even the desk gets "chibi-fied." Can you spot a pattern in the third frame of all the examples you have seen so far? At least one character tries to regain composure after resuming normal size. In this instance, the girl wipes a tear of laughter from her cheek. Actions like these help maintain the continuity from one panel to the next. This "composure step" isn't mandatory, and in some manga it's omitted. It's a matter of personal taste. I prefer it. I think it helps the flow of the story.

Embarrassment

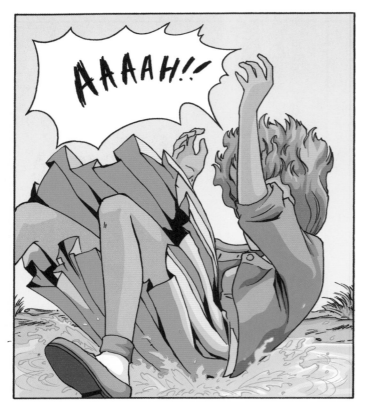

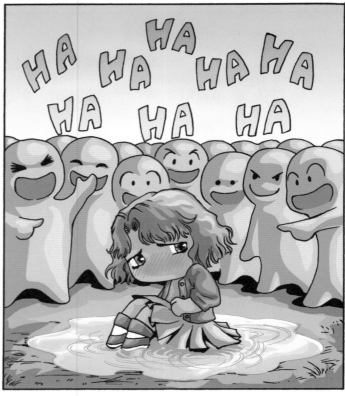

Embarrassment is a strong emotion, and if the moment is humiliating enough, it can trigger a super-deformed transformation. But simply falling in a puddle won't do it. Let's set the scene: She falls in front of the boy on whom she has a crush, but who never notices her. And this day, she wore her best dress, just to get his attention. Yep. That'll do it.

In the second panel, she super-deforms into a chibi. To make matters worse, we'll add a group of people laughing at her in the background. Notice that it is her imagination that has created the entire scene to reflect what she's feeling: a huge group of people—also super-deformed—are gathered around to laugh at her. Of course, these people exist only in her mind: there's really no one there but a boy who is trying to help—the boy she has a crush on. But it's all about what she's feeling inside. Therefore, the super-deformation works as a reflection of an inner monologue.

Super-Deformed Characters as Critics

Another fun way to use super-deformed characters is to feature them in the corners of panels, commenting to the reader, or to each other, on what's happening inside the panel. Although these are actually chibis, shrunk down to super-miniature size, when they comment on a story in this manner, they're referred to as "super-deformed" characters.

These super-deformed chibis aren't part of the story, but outside of it. Perhaps you've seen a similar device used by political cartoonists on the editorial pages of major newspapers. Some Pulitzer Prize–winning cartoonists use this technique. But in comic books, it is unique to manga. Like any device, you can overuse it if you put it on every page. However, fans enjoy it, and so these commenting chibis are typically sprinkled throughout a graphic novel. Most often, these super-deformed commentators show up in the last panel of a page, so as not to stop the flow of action midway through the story. Often times, manga authors will save several pages at the end of their graphic novel to devote exclusively to super-deformed characters. In this situation, the super-deformed characters chat about the author and his or her interests (fans like that) as well as upcoming stories—they will even grouse about the stories.

TO BE CONTINUED...

Critics on the Side of the Panel

Sometimes there's just too much stuff going on in the panel—leaving no room to place the super-deformed characters. In those cases, you can place your super-deformed characters off to the side.

I LOVE YOU!

F-FINALLY!

WAY TO WAIT UNTIL THE LAST DAY OF CAMP, ROMEO

EVIL FORCES... DESTINY... CHOSEN ONES... BLAH BLAH BLAH

HE SURE TALKS A LOT.

YEAH. YOU'RE NEW, HUH?

Notice that the super-deformed chibis' costumes mirror that of the main characters.

MAGIC TRANS-FORM!

HOW COME YOU NEVER DRAW ME? AREN'T I PRETTY ENOUGH?

DO I HAVE TO ANSWER?...

Critics in the Corners

The corner is the most popular place for chibi-sized commentators to offer their verbal jabs. The eye is always drawn to a corner when an object is placed there, so it's strategically a good place to put the little chibis. Placed in a corner, the super-deformed chibis are able to attract the eye without obstructing the larger picture.

Using the Panel Borders as a Curtain

You can have fun breaking reality by having a chibi lift the panel line in order to make room for herself. Chibis can be funny critics, offering scalding, running commentaries. Find inventive ways of introducing your super-deformed characters and you'll keep your readers amused and wanting more.

Chibi Greeting Cards and Logos

Chibis look great in costumes and in silly roles, and their cheerful innocence and good-natured mischievousness is the perfect blend for greeting cards. What follows are some examples of how you can use chibis for greeting cards, posters, announcements, stationery, and Web site logos.

Halloween Chibi

Halloween is a huge holiday. In fact, most candy companies do the majority of their annual business during the short Halloween season. Candy companies are always looking for new ways to promote tooth decay. So instead of an ugly old witch, try a cute, chibi-style witch for a fresh twist on the theme. The chibi witch, with her cheerful expression, portrays the light-hearted, rather than horror-oriented, aspect of this popular holiday.

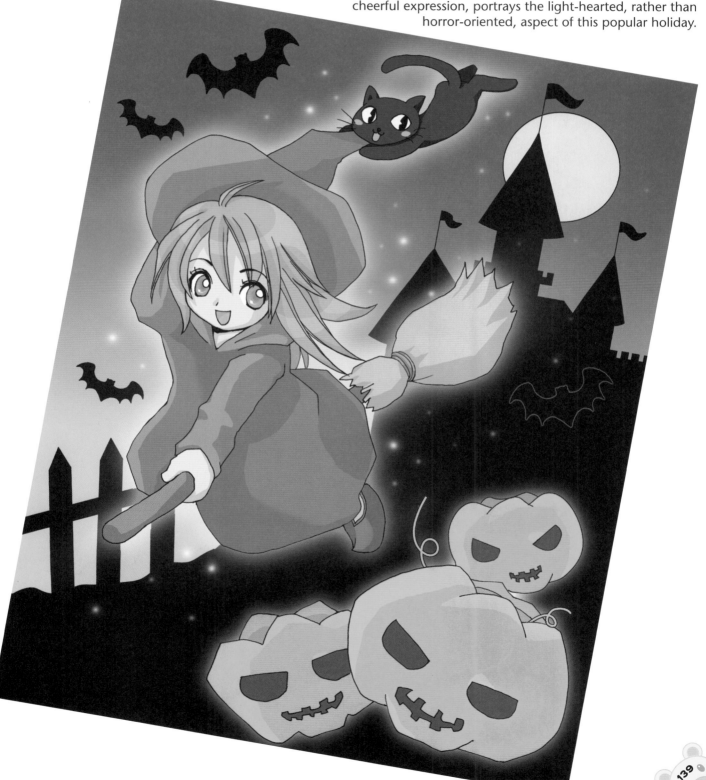

Valentine's Day Chibi

We're all kids at heart. And we all remember our first crush. Chibis bring out that earnestness of a time long ago. The world of chibis is so optimistic that it drowns out the worries of the world. Even the two pups in the picture are celebrating!

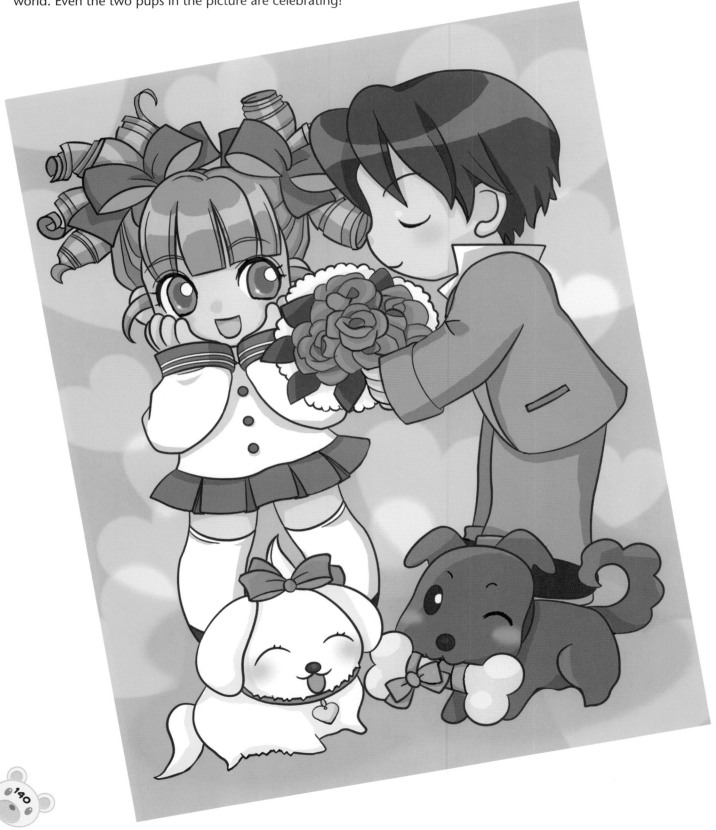

Birthday Chibi

See what happens when you leave the batter around a chibi? They just can't resist. I told you they were naughty.

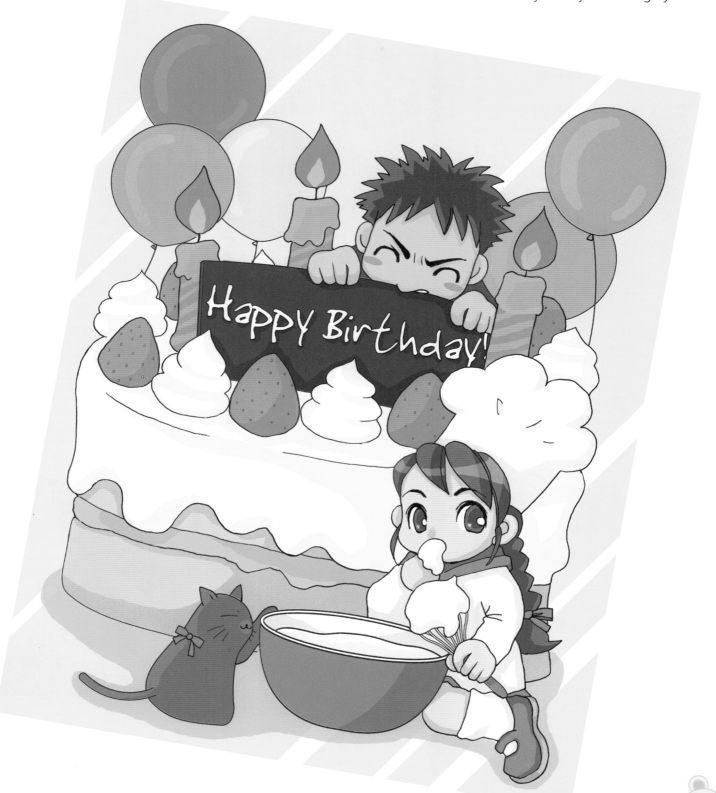

Christmas Chibi

When Santa goes on vacation, the chibis take
over, with the assistance of holiday elfin helpers.

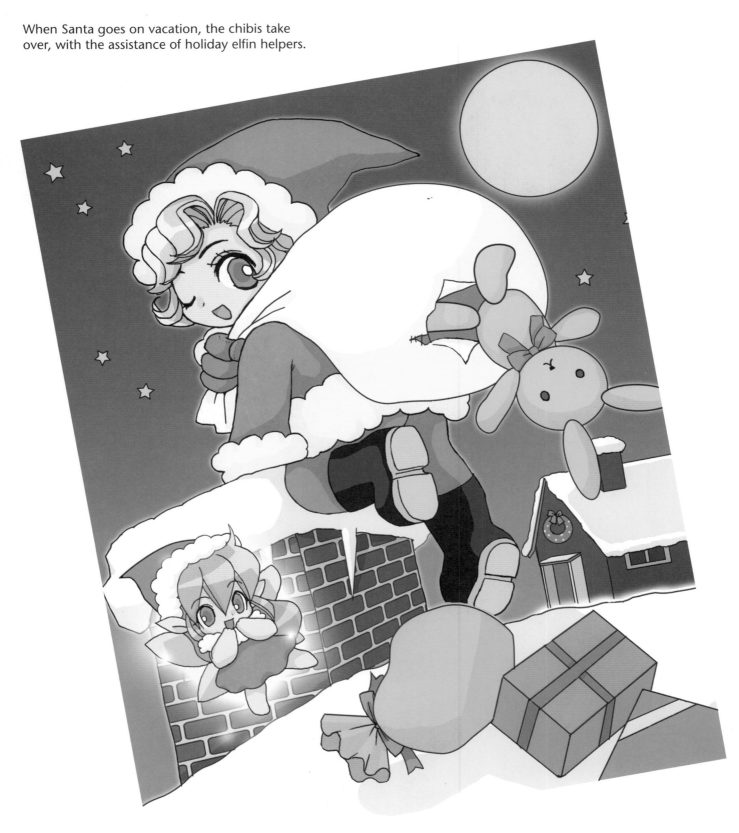

Graduation Chibi

Now he's ready to take on the world, or at least the next grade!

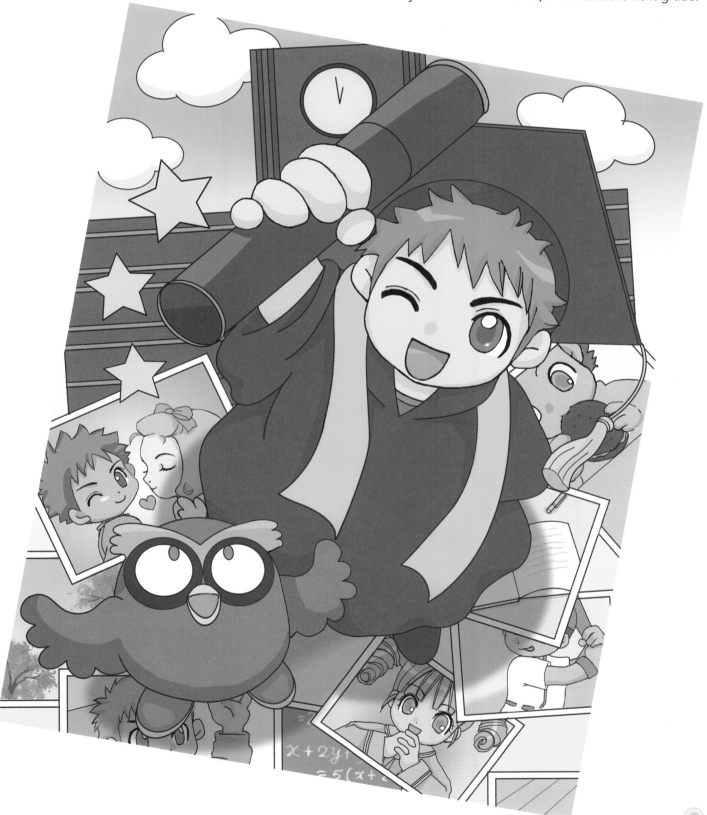

Index